Perfect Likeness

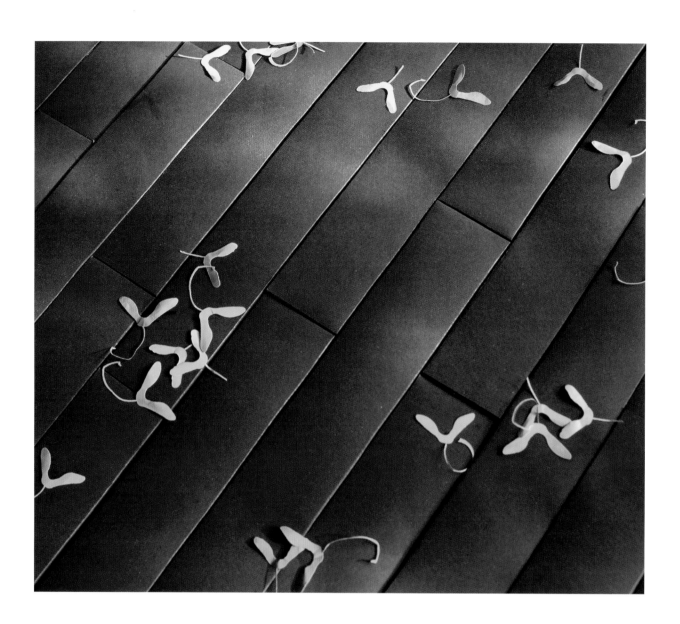

# Perfect Likeness

## Photography and Composition

RUSSELL FERGUSON

Hammer Museum
University of California, Los Angeles

DelMonico Books · Prestel
Munich  London  New York

*Perfect Likeness*
is dedicated to the memory of
Karin Higa.

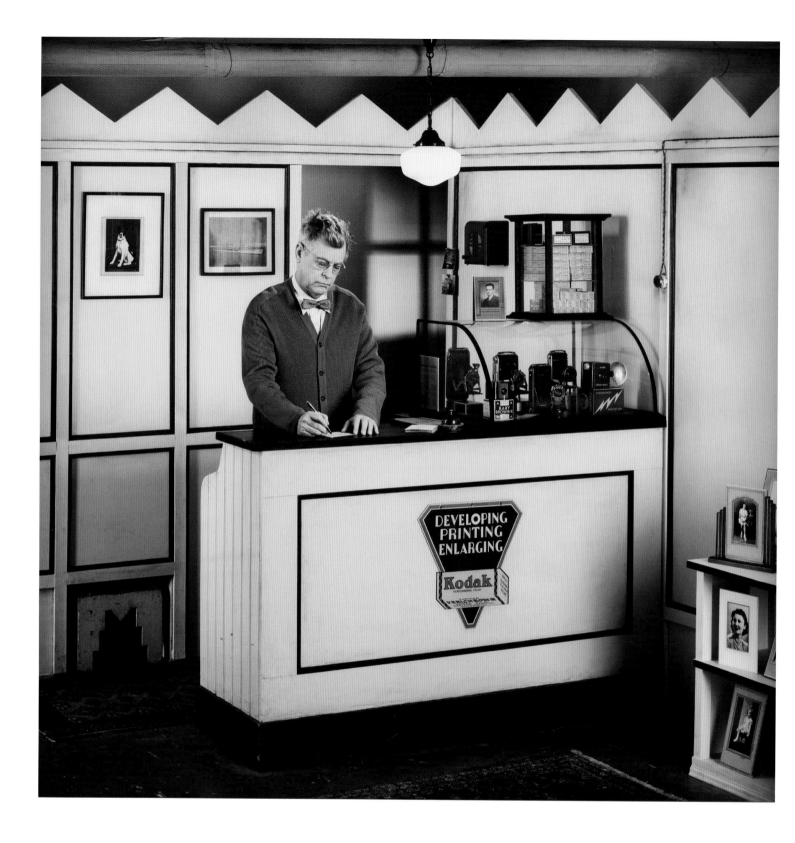

FRONTISPIECE Thomas Demand
*Daily #11*, 2009

ABOVE Rodney Graham
*Small Basement Camera Shop circa 1937*, 2011

The Hammer Museum is proud to present *Perfect Likeness: Photography and Composition*. The museum has an ongoing commitment to presenting contemporary photography. In recent years, survey exhibitions of the work of Robert Heinecken, Wolfgang Tillmans, and James Welling have been cornerstones in our program. We have also presented a number of shows that have taken a fresh look at particular media. These have included *Thing* (2005), which explored the sculpture of emerging artists in Los Angeles; *International Paper* (2003), which focused on drawing; and *The Undiscovered Country* (2004), which looked at various approaches to representation in painting. *Perfect Likeness* continues this tradition. Photography now has a ubiquitous presence in our daily lives. This exhibition examines not the everyday flood of images but rather the presence of individual, carefully considered and composed images by contemporary artists working with photography.

I am extremely grateful to the institutions that have entrusted us with their works of art: The J. Paul Getty Trust, Los Angeles; Los Angeles County Museum of Art; The Metropolitan Museum of Art, New York; Modern Art Museum of Fort Worth; Museum of Contemporary Art Chicago; The Museum of Contemporary Art, Los Angeles; The Robert Mapplethorpe Foundation, New York; Rubell Family Collection, Miami; and Walker Art Center, Minneapolis. I also thank the private collectors who have generously agreed to share their works with a larger audience: Rosette V. Delug, Jason Frank and Jerry Johnson, Linda and Bob Gersh, Alan Hergott and Curt Shepard, Hort Family Collection, Andrew Marks, Viet-Nu Nguyen, Heather Podesta, Matthew and Sarah Rothman, Barbara Ruben, David Simkins, Allison Wong, and those who wish to remain anonymous.

I am deeply appreciative of the donors who made this catalogue and exhibition possible. We are delighted to have major support for this project from Susan Steinhauser and Daniel Greenberg/The Greenberg Foundation. They have been stalwart and generous supporters of the Hammer over many years. We are also grateful to Eugenio Lopez and The Andy Warhol Foundation for the Visual Arts, both invaluable and longtime partners for the Hammer's exhibitions. Additionally, we thank The Audrey and Sydney Irmas Charitable Foundation, the National Endowment for the Arts, the Pasadena Art Alliance, The Robert Mapplethorpe Foundation, Contemporary Collectors-Orange County, Trish and Jan de Bont, Cyndee Howard and Lesley Cunningham, Margo Leavin, and Suzanne Deal Booth for their generous funding. Special thanks go to Matthew Marks Gallery for its support of this catalogue.

*Perfect Likeness* was thoughtfully developed and skillfully organized by Russell Ferguson, UCLA professor and Hammer adjunct curator, and I am pleased by his continued involvement with the museum. I also thank the Hammer's staff for their daily efforts in producing another wonderful catalogue and exhibition.

My greatest thanks go to the artists represented in the show. Their work has already proven to be highly influential, and will no doubt continue to inspire other artists in the future.

ANN PHILBIN, DIRECTOR

RUSSELL FERGUSON

# Perfect Likeness

When we say of a portrait that it is a perfect likeness, we mean not just that it accurately delineates its subject. It is implied that the image goes beyond surface appearance to give us some deeper sense of the person depicted. The same logic can be applied more broadly. There was a time when it seemed a plausible goal for an artist to resolve a picture so conclusively that the result of his or her work would transcend simple representation. Today such a project can seem naïve. We are glutted with images. Douglas Crimp argued that "firsthand experience begins to retreat, to seem more and more trivial. While it once seemed that pictures had the function of interpreting reality, it now seems that they have usurped it."[1] For many, the very idea of an unmediated reality has begun to seem implausible, the culmination of an argument advanced as early as 1945 by Theodor Adorno, who wrote then that "the objective tendency of the Enlightenment, to wipe out the power of images over man, is not matched by any subjective progress on the part of enlightened thinking towards freedom from images" and that "representation triumphs over what is represented."[2] The implication is clear: the torrent of images does not clarify but rather obscures.

It is of course the camera that has enabled such a flood. More photographs are now taken every day than in the first hundred years of photography's existence. In the early days of the medium every image was a quintessential image, since whatever was depicted was recorded for the first time, but the nineteenth century was not yet over before the critic Sadakichi Hartmann could write:

> *Amateur photography, apparently accessible to every one who can press the button, and reminding one, even with the crudest handling, somewhat of pictorial art, has taken hold of the public taste to such an extent that the Kodak fiend has been made into a typical figure and has had to play his ridiculous part on the stage and in the comical magazines for years.*[3]

1    Douglas Crimp, "Pictures," in *Pictures* (New York: Artists Space, 1977), 3.
2    Theodor Adorno, *Minima Moralia* (1951), trans. E. F. N. Jephcott (London: Verso, 2005), 140.

3    Sadakichi Hartmann, "A Few Reflections on Amateur and Artistic Photography" (1898), in Jane Calhoun Weaver, ed., *Sadakichi Hartmann, Critical Modernist: Collected Art Writings* (Berkeley: University of California Press, 1991), 99.

By 1930 Christopher Isherwood could use the metaphor of the camera to represent precisely a *renunciation* of choice: "I am a camera with its shutter open, quite passive, recording, not thinking."[4] Subsequently the very idea of a fully controlled picture came for many to seem a pointless–or impossible–idea. For John Berger, writing in the 1960s, "photographs are records of things seen. Let us consider them no closer to works of art than cardiograms." What's more, "composition in the profound, formative sense of the word cannot enter into photography." Unless, Berger adds dismissively, "we include those absurd studio works in which the photographer arranges every detail of his subject before he takes the picture."[5]

Roland Barthes feared that the power of the photograph would be drained by its successful transmutation into art. It would be rendered banal, "no longer confronted by any image in relation to which it can mark itself, assert its special character, its scandal, its madness. This is what is happening in our society, where the Photograph crushes all other images by its tyranny."[6] Echoing Barthes, Walead Beshty has pointed out that "when confronted with a world of appearances, the irony is that the only tool left to combat the tyranny of images is yet more."[7] For artists who began their work in the era of unlimited and ubiquitous images, however, it was perhaps inevitable that at some point there would be a turn away from the glut to reexamine the possibility of making work that could claim a singularity.

The artists whose works are included in this exhibition are not content to add more images to an endless stream. They are looking to make pictures that can lay claim to the autonomy long associated with the work of art. This is a question for painters too, of course, but it is most urgent for artists working in photography, a medium that pervades every corner of daily life in a way that massively overflows the field that we call art. As Crimp wrote, "photography will always exceed the institutions of art, always participate in nonart practices, always threaten the insularity of art's discourse."[8] But then, perhaps it is the prevalence of nonart photographs that makes it possible to identify those that are in fact art. Everyone writes, but we can distinguish between an invoice and a poem.

It is true, of course, that composition in painting is itself a contested territory. For a hundred years now, various aleatory strategies have been put into play by painters seeking to avoid compositional conventions. Despite this, artists who work with photography–perhaps in part *because* of its capacity for chance juxtapositions and serial production–continue to be drawn to the possibility of making pictures that stand

4   Christopher Isherwood, "A Berlin Diary (Autumn 1930)," in *Goodbye to Berlin* (1939; reprint, New York: New Directions, 2012), 3.

5   John Berger, "Understanding a Photograph" (1968), in Geoff Dyer, ed., *John Berger: Selected Essays* (London: Bloomsbury, 2001), 216.

6   Roland Barthes, *Camera Lucida*, trans. Richard Howard (New York: Hill and Wang, 1981), 117, 118.

7   Walead Beshty, "Abstracting Photography," in *Words without Pictures* (Los Angeles: Los Angeles County Museum of Art, 2009), 304.

8   Douglas Crimp, "Appropriating Appropriation," in *Image Scavengers: Photography* (Philadelphia: Institute of Contemporary Art, 1982), 33.

alone. "I try to make each picture in some level of isolation from any other, to make them singular," Jeff Wall has said. "I like the sense that each picture is complete in itself."[9] And equally, an artist who works in quite a different way to Wall, Wolfgang Tillmans, has said: "I do want each picture to be understood as its own self-sufficient entity."[10] Any attempt to achieve this level of autonomy will lead inevitably to the question of composition. How does one make a picture with that kind of autonomous presence?

Beshty has argued that "the term 'image' is not an ontological umbrella under which a photograph can be classified, but a conceptual tool that functions in a particular way."[11] Beshty himself has insisted on a materialist conception of photography based on the distinction between the photographic object and the image. He rejects contemporary art photography's "almost obsessive adherence to Renaissance pictorial formulae."[12] The photograph is not just an image: it is also a physical object with a three-dimensional presence in the world. There is no reason in principle why a photograph should not make the claim to completeness without representation that, say, a plank sculpture by John McCracken does. As McCracken described his practice, "I think of essences–trying to get at the soul of things, trying to pare down to just what's needed."[13] Many artists working with photography have sought that same distilled quality, a purity that is in many ways antipictorial. Elad Lassry remembers that as a graduate student, "I was really against making pictures, and yet I was still making them somehow. So I was, in part, tormented."[14] While the camera always leans in the direction of representation, it simultaneously offers itself as a vehicle for all kinds of methodologies, including abstraction. "If Ideas are given, in the cave, in the form of reflections or shadows," François Laruelle has written, extending Susan Sontag's argument in "In Plato's Cave," "would they not, if they could be given directly to the sensible, give themselves in the form of photos?"[15]

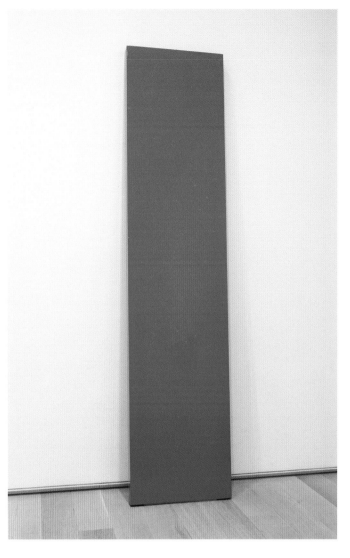

John McCracken
*Red Plank*, 1969

9   Jeff Wall, interview with Yilmaz Dziewior, in *Jeff Wall: Tableaux Pictures Photographs 1996–2013* (Bregenz, Austria: Kunsthaus; and Amsterdam: Stedelijk Museum, 2014), 38.
10   Wolfgang Tillmans, in Hans Ulrich Obrist, ed., *Wolfgang Tillmans* (Cologne: Walther König, 2007), 93.
11   Beshty, "Abstracting Photography," 304.

12   Ibid., 305.
13   John McCracken, artist's statement (1999) in James Meyer, ed., *Minimalism* (London: Phaidon, 2000), 291.
14   Elad Lassry, "On Display," interview with Mark Godfrey, *Frieze*, no. 143 (November–December 2011): 91.
15   François Laruelle, *The Concept of Non-Photography* (Falmouth, UK: Urbanomic; and New York: Sequence, 2012), 77; and Susan Sontag, "In Plato's Cave," in *On Photography* (1973; reprint, New York: Anchor, 1990).

How might one make an image of an abstract idea that could potentially exist as a concept entirely outside the field of representation? Hiroshi Sugimoto's Conceptual Forms–photographs of mathematical models from the late nineteenth and early twentieth centuries–are records of attempts to represent trigonometric functions in three-dimensional form. *Conceptual Forms 0003* (2004, see p. 118 for complete title) shows a model of Dini's surface, defined as "a surface of constant negative curvature obtained by twisting a pseudosphere." The photograph shows a supremely elegant form, dramatically lit and emerging out of the darkness behind it, the representation of a concept. Yet it is impossible not to notice that the model has a few chips along its edges. It calls to mind the object that André Breton found at a Paris flea market in the 1920s, an "irregular, white, shellacked half-cylinder covered with reliefs and depressions that are meaningless to me" when he went searching for objects that were "old-fashioned, broken, useless, almost incomprehensible."[16] No matter how pure the subject, the camera will always find these nicks, the tiny blemishes on the surface. And so the link between the photograph and representation cannot be easily cut. Whether it is William Henry Fox Talbot, one of the inventors of the medium, speaking of "a shadow…fixed for ever in the position which it seemed only destined for a single instant to occupy"[17] or Crimp's assertion that we now "only experience reality through the pictures we make of it,"[18] the link

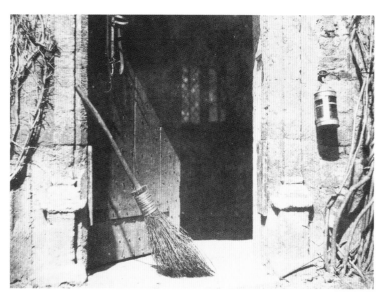

William Henry Fox Talbot
*The Open Door,*
before May 1844

between the photograph and its representational power remains unbroken. No matter how much the artist tries to eliminate contingent detail from his or her picture, the camera's relentlessly indexical capacity persistently reinscribes the tactile grain of reality.

Henry Peach Robinson is usually credited with originating the term "pictorial photography." Working in the mid-nineteenth century, Robinson wanted to make photographs that were not simply documentary records. He wanted to make pictures. And of course the pictures he made were in the sentimental narrative vein of the Victorian era. His best-known work is *Fading Away* (1858), a fictional deathbed scene.

16  André Breton, *Nadja* (1928), trans. Richard Howard (New York: Grove Press, 1960), 52.

17  William Henry Fox Talbot, "Some Account of the Art of Photographic Drawing" (1839), in Vicki Goldberg, ed., *Photography in Print* (Albuquerque: University of New Mexico Press, 1981), 41.
18  Crimp, "Pictures," 3.

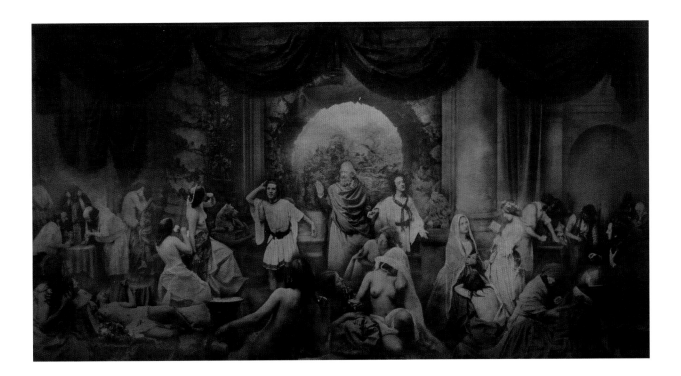

Its construction–five different negatives patched together to create effects unobtainable in a single shot–seems to prefigure some of today's ways of treating the photograph (his contemporary Oscar Gustave Rejlander's *The Two Ways of Life* [1857] was constructed from *thirty* different negatives), but this way of working quickly faded away itself, as photographers began to realize that the medium's greatest strength lay not in the attempt to duplicate the storytelling of contemporary painting but rather in the appeal it could make to being a simple record of whatever was in front of the camera. This was already true in the 1850s: the success of *Fading Away* was accompanied by protests that Robinson had forced himself on such a scene with his camera. The assumption was in place that the photograph had a special claim on authenticity and truth. Robinson's staged scene was not received as fictional, and thus seemed offensive and intrusive. Only in recent years has there been a return to the possibilities of synthetic picture making in photography unrelated to implicit claims of truth telling.

Oscar Gustave Rejlander
*The Two Ways of Life*, 1857

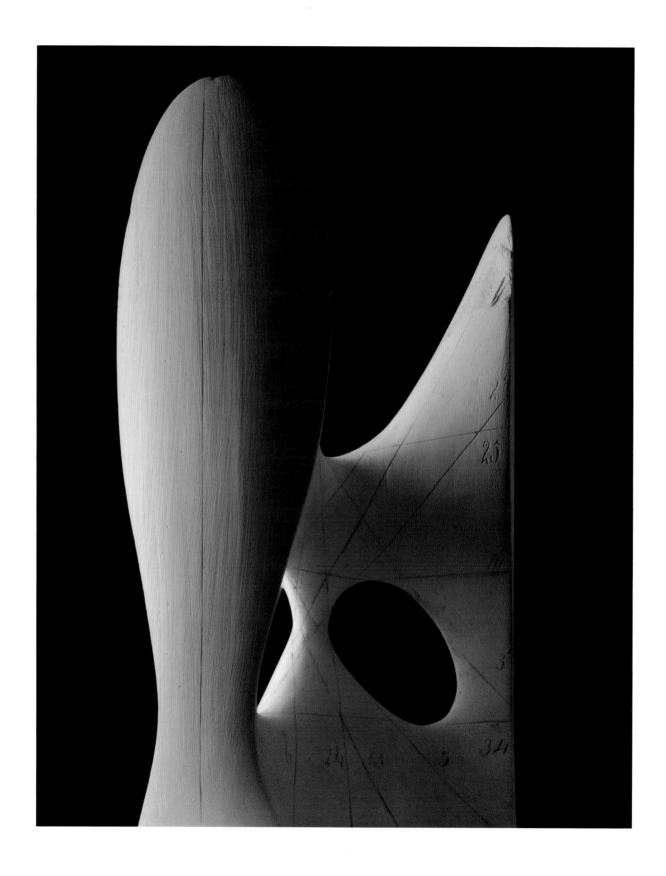

Hiroshi Sugimoto
*Conceptual Forms 0012*
*Diagonal Clebsch surface, cubic with 27 lines*, 2004

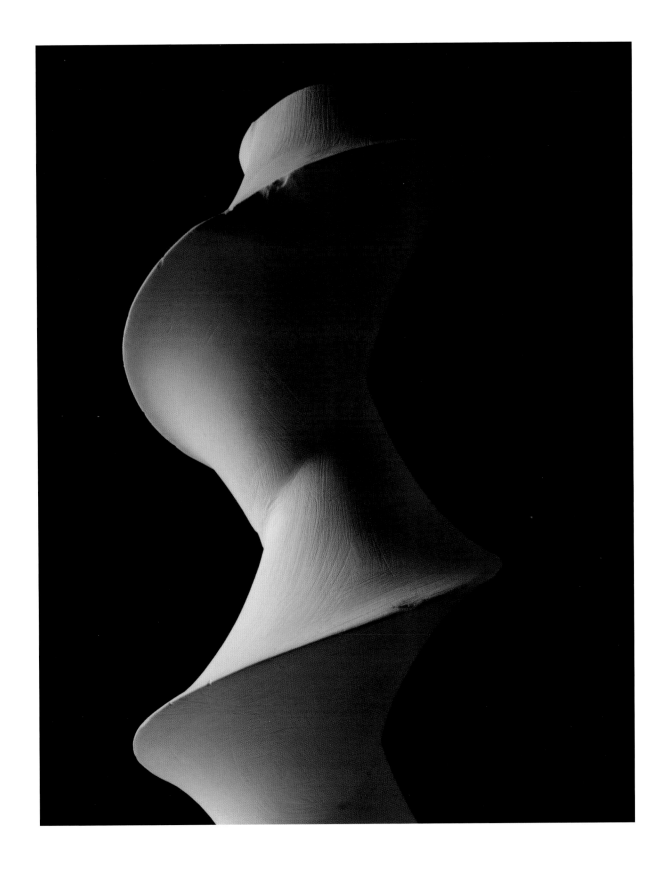

Hiroshi Sugimoto
*Conceptual Forms 0003*
*Dini's Surface: a surface of constant negative curvature*
*obtained by twisting a pseudosphere,* 2004

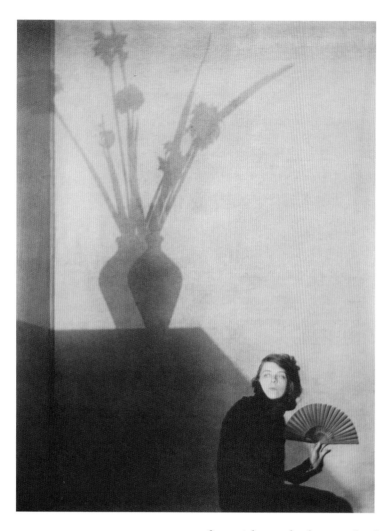

Edward Weston
*Epilogue*, 1919

In the early decades of the twentieth century, photographers with aesthetic ambitions continued to take painting as their model. When the elaborate allegories and sentimental narratives of early pictorialism lost ground, it was to the influence of Tonalism. This movement, however, simply continued to follow contemporary trends in painting. Soft, moody, almost blurry compositions now seemed the most artistic way for photography to proceed. In the late nineteenth century Alfred Stieglitz was the American champion of this tendency and disseminated it through his influential journal, *Camera Work*. For Stieglitz, the creative part of photography was the darkroom manipulation of the negative.

In the 1920s Edward Weston began to move away from soft images toward a crisper, more focused approach. The key area in which he broke with Stieglitz was his belief that "*the finished print must be created in full before the film is exposed*."[19] The work of the photographer was presumed to take place entirely before the shutter was released, when the composition of the image would take place in the mind's eye. By the early thirties Weston had founded the group f/64 with Ansel Adams and others, for whom sharp focus and "straight" photography was now a sine qua non. Adams was explicit that he considered "all phases of manipulation of negatives and prints, all diffused-focus, retouched, etched, colored, multi-toned or pigmented images entirely beyond the strict limitations of the photographic medium."[20] From today's pluralist perspective this kind of declaration that certain techniques are simply unacceptable seems almost quaint. But such prescriptions exerted enormous influence.

Nevertheless, while Weston and Adams continued to make classically composed and conventionally beautiful images, they were succeeded by others who—without wishing to return to pictorialism—were dissatisfied with the tasteful elegance of f/64 work. There has been widespread suspicion among serious photographers ever since of images that are too beautiful, too "photogenic," or too well composed. The availability

19  Edward Weston, "Seeing Photographically" (1930), reprinted in Alan Trachtenberg, ed., *Classic Essays on Photography* (New Haven, CT: Leete's Island Books, 1980), 172. Italics Weston's.

20  Ansel Adams, "An Exposition of My Photographic Technique," *Camera Craft* 41 (January 1934): 19.

of handheld 35mm cameras made it possible to work with minimal preparation and in a wider range of light. This greatly increased the possibilities of pictorial innovation. Since so many practitioners of this way of working took many photographs outside the studio, the term "street photography" is often used to describe their work.

The term, however, is also shorthand for a much wider scope of work than the term might suggest if taken literally. The key elements, whether strictly street photography or not, were spontaneity, a refusal of conventional finish and pictorial coherence, and ultimately a desire to find pictures that worked despite apparently chaotic composition. Photographers from Robert Frank and Garry Winogrand to William Klein and Daido

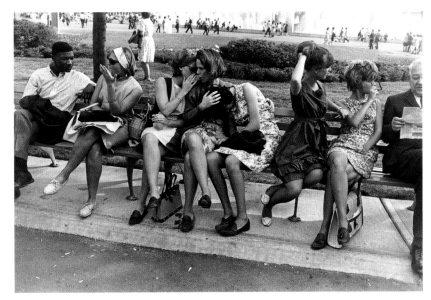

Moriyama were all resistant in different ways to standard ideas of composition. They introduced a variety of strategies to counteract it: jumbles of figures; people cut in half by the edge of the frame; drastically over- or under-exposed shots. They were open to chance and accident in every aspect of their work. As Wall has described this, "Every picture-constructing advantage accumulated over centuries is given up to the jittery flow of events as they unfold. The rectangle of the viewfinder and the speed of the shutter, photography's 'window of equipment,' is all that remains of the great craft-complex of composition."[21] Above all it was necessary to avoid the picturesque, because the picturesque could often be difficult to distinguish from commercial work or from amateur photography. Those pictures had already been made, and to make them again came perilously close to kitsch.

21  Jeff Wall, "'Marks of Indifference': Aspects of Photography in, or as, Conceptual Art" (1995), in Wall, *Selected Essays and Interviews* (New York: The Museum of Modern Art, 2007), 146.

At the same time, however, there have always been photographers unconcerned by such connotations. For them, as for Keats,

*Beauty is truth, truth beauty,–that is all*
*Ye know on earth, and all ye need to know.*[22]

Lynn Davis's photographs of icebergs off Greenland take their massive, irregular forms as exemplars of beauty, and she presents them as if they were gigantic works of art in their own right. There is no attempt to undercut their presence by aggressive cropping, or to introduce bathetic effects in the form of incongruous human presence. After studying with Imogen Cunningham, Davis had spent many years making uncomposed street photographs and working as a photojournalist. Her iceberg photographs came out of a desire to eliminate much of the contingent detail from her work. Her way of composing now, she says, was "born of emptiness."[23] The photographs manifest a longing for pure form treated unapologetically as an aesthetic experience.

Perhaps no photographer discussed here embraced the Keatsian position more explicitly than Robert Mapplethorpe. He was looking for perfection in his work and avoided anything that would obstruct this primary goal.

*Perfection means you don't question anything about the photograph. There are certain pictures I've taken in which you really can't move that leaf or that hand. It's where it should be, and you can't say it could have been there. There's nothing to question as in a great painting. I often have trouble with contemporary art because I find it's not perfect. It doesn't have to be anatomically correct to be perfect either. A Picasso portrait is perfect. It's just not questionable. In the best of my pictures, there's nothing to question–it's just there.*[24]

Mapplethorpe, like so many photographers who are concerned with composition, evokes painting as the standard to which the photograph should aspire. The pursuit of this standard led him to ignore the various strategies for undercutting the picturesque used by other photographers. His ideal, in fact, was a classical perfection that in many ways linked him more closely to nineteenth- or early twentieth-century photographers than to the generation that immediately preceded him; like those earlier photographers, he looked to painting as a model of composition. He wanted to have photography accepted on equal terms with painting, by no means a given in the 1970s.

22   John Keats, "Ode on a Grecian Urn" (1819).
23   Lynn Davis, conversation with the author, September 24, 2014.

24   Robert Mapplethorpe, interview with Janet Kardon, in *Robert Mapplethorpe, The Perfect Moment* (Philadelphia: Institute of Contemporary Art, 1988), 28. Mapplethorpe and Davis were friends. Patti Smith describes visiting Mapplethorpe just before he died, and makes the connection between their work: "I lingered by his empty wheelchair. Lynn Davis's image of an iceberg, rising like a torso turned by nature, dominated the wall." Smith, *Just Kids* (New York: Ecco, 2010), 275.

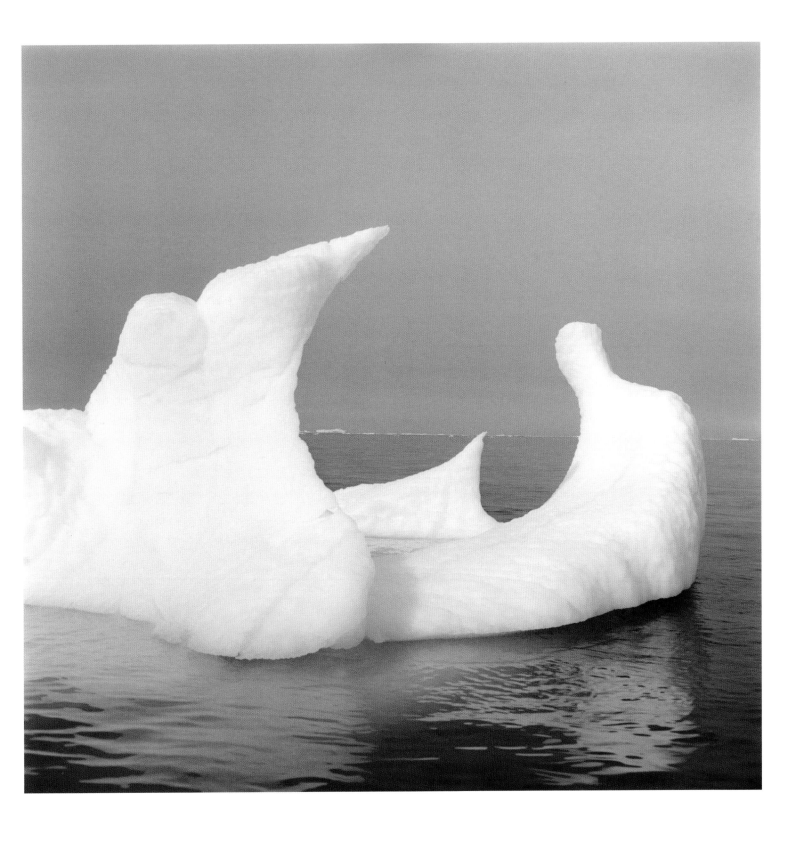

Lynn Davis
*Iceberg 32, Disko Bay, Greenland*, 2000

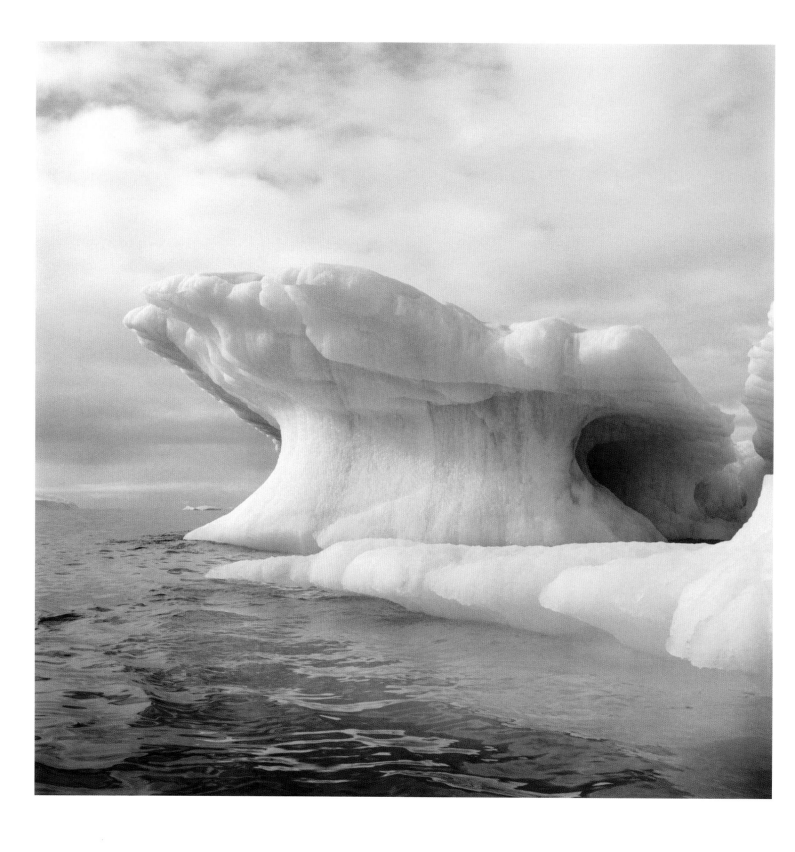

Lynn Davis
*Iceberg III, Disko Bay, Greenland*, 2004

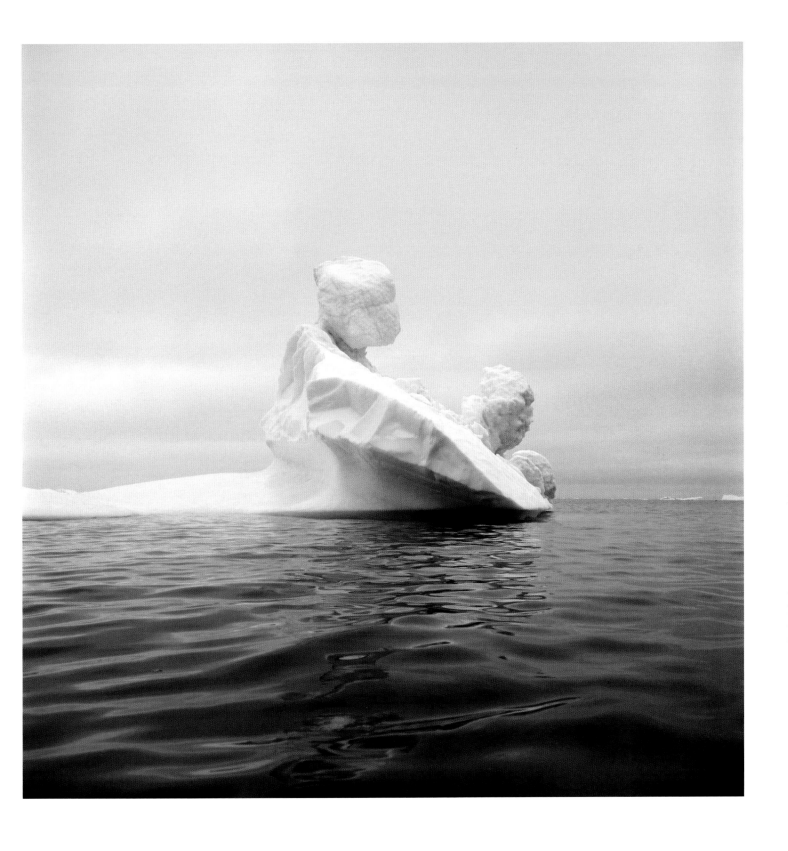

Lynn Davis
*Iceberg IX, Disko Bay, Greenland*, 2004

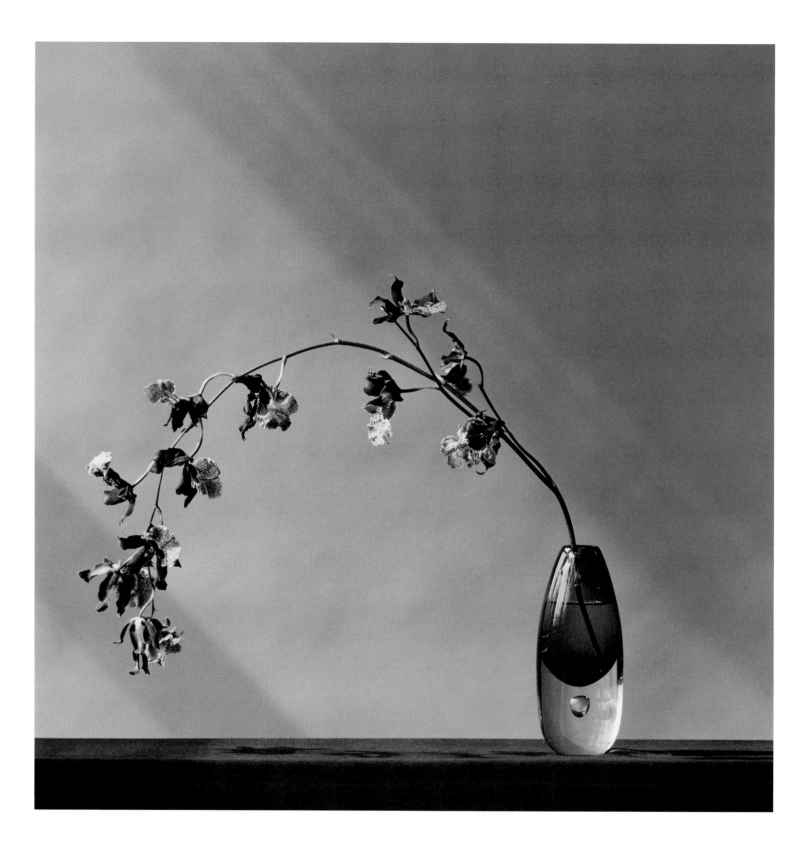

Robert Mapplethorpe
*Orchid*, 1982/2005

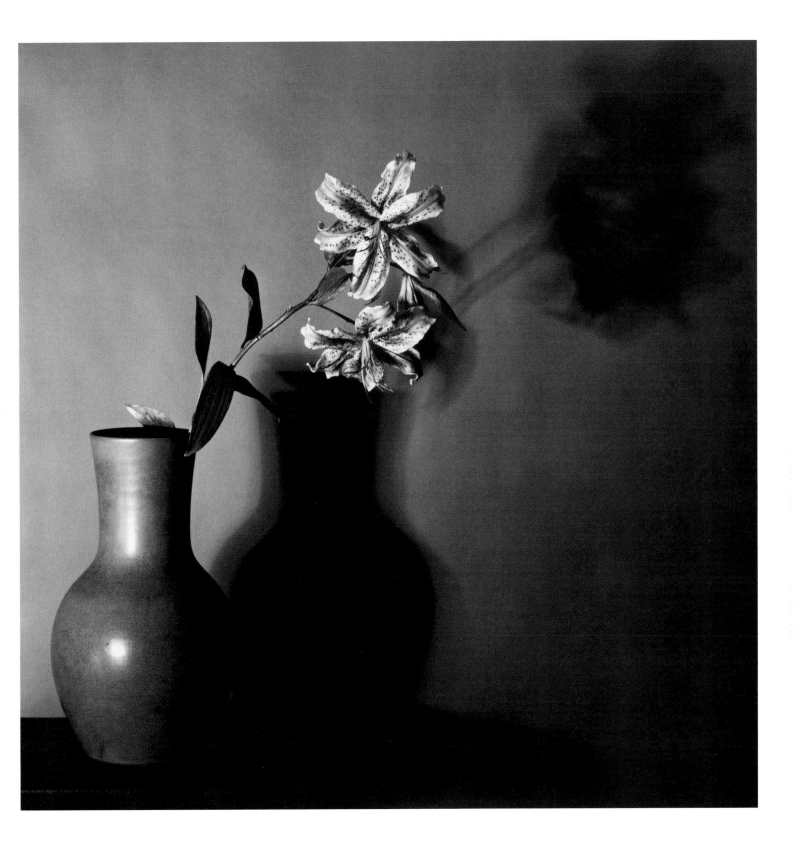

Robert Mapplethorpe
*Lily*, 1979/2006

To make work that engages with the idea of the overtly composed image means disregarding many tacit taboos of art photography. Such images can be in conflict with the long-established mandate of photography to present a supposedly unmediated representation of the world as the photographer finds it. In part, this turn away from a method of working rooted in the tradition of street photography was a consequence of that approach having come to seem fully developed by the canonical figures of the genre. As Wall has said, speaking in particular of the work of Walker Evans and Robert Frank, "It seemed like those people had pretty much perfected this kind of photography–the small photograph of the real world, made somehow in the actual, and ending up in a book. It was the perfect form of reportage as art–and it seemed there was nowhere to go after them. I saw it as a closed door."[25] Wall is expressing the universal reluctance of ambitious young artists to follow too closely along the path laid out by their predecessors. If Evans and Frank owned their turf too completely, then it would be necessary to find another space in which to operate. Wall's work of the 1980s emphasized a certain artificiality, in part to distinguish it from the photographs of earlier generations.

But beyond the straightforward need to find one's own way of working, the earlier generation's implicit claim to a unique level of authenticity had already begun to crumble. The moving image is now almost as ubiquitous as the photograph, and perhaps more credible. At the same time, the universal availability of image-altering digital technologies has undercut photography's once unassailable claims to a truth in representation unavailable to other media. Since the photographic image is now almost infinitely amenable to whatever alterations and refinements the photographer sees fit to make, the medium itself is slowly reverting to a picture-making apparatus as much as a vehicle for unvarnished truth. This has opened a space for artists to return to ways of working–and of composition–that were largely abandoned in the earliest days of photography.

Even the great figures of street photography thought about their compositions, however, and made various adjustments to achieve the effects that they wanted. As Sontag wrote, "despite the presumption of veracity that gives all photographs authority, interest, seductiveness, the work that photographers do is no generic exception to the usually shady commerce between art and truth." And even those with the greatest integrity and commitment to authenticity (she cites Evans and Dorothea Lange) "would take dozens of frontal pictures of one of their

Dorothea Lange
*Pea picker from Texas*, 1935

25  Wall, quoted in Jane Ure-Smith, "New Artistic Directions for Photographer Jeff Wall in Amsterdam," *Financial Times*, February 14, 2014.

Jeff Wall
*Intersection*, 2008

sharecropper subjects until satisfied that they had gotten just the right look on film— the precise expression on the subject's face that supported their own notions about poverty, light, dignity, texture, exploitation, and geometry."[26] Henri Cartier-Bresson would stake out his territory and his light, then wait for the right passerby to complete his classically composed picture: baiting the trap, he called it.

This is in fact the way Wall composed *Intersection* (2008), one of his otherwise unstaged works. As he says, "Lots of photographs are composed by placing the camera and choosing the time of day."[27] And yet it is hard to keep the balance between the found scene and the decisions of the photographer. Tillmans has well expressed the tension between the impulse simply to record and the competing pull of making one's intervention recognizable. "The decisive thing is not to expose the act of manipulating

26  Sontag, "In Plato's Cave," 6.
27  Wall, conversation with the author, November 19, 2014.

coincidence. But this is a temptation that's hard to resist because you want to show that you did it yourself–that you were there, that it wasn't sheer coincidence, but, rather, that you willed it. This desire to show authorship in art has a negative effect on many works."[28]

John Szarkowski estimated that in Los Angeles between 1978 and 1984, Winogrand exposed several hundred thousand frames that he never printed nor probably even looked at. Working with a motor-driven film advance, he pressed the shutter release of his camera over and over again "like an overheated engine that will not stop even after the key has been turned off," as Szarkowski put it. "It is as though the making of an exposure had become merely a gesture of acknowledgment that what lay before the camera might make a photograph, if one had the desire and the energy to focus one's attention."[29]

This vision of the shutter clicking all day long is the disturbing polar opposite of the photographer as image crafter in search of the perfectly composed picture. In his earlier years, of course, Winogrand had set the standard for unorthodox yet convincing compositions taken without preparation from the everyday life of the street. He took his images directly and was opposed even to cropping the results. Yet the motor-driven and compulsive shooting of his later years sets the outer limit for what it means to make a picture. Is it a picture if no one ever sees it? If the photographer never even looks at it? This marks the reductio ad absurdum of the idea of the street as a river of the real from which one can always draw water in the form of photographs. In the end, this is the point at which a return to images that are carefully conceived and carefully executed becomes inevitable.

But the subject itself need not have any grandeur or obvious allegorical significance. As Ad Reinhardt wrote, "If you like a 'picture' of trees, cows, and nudes you like trees, cows, and nudes."[30] Artists might like these things too, but there is more to making a work of art. Wall's *Diagonal Composition* (1993) is a photograph of a dirty sink with a bar of dirty soap lying on it. Wall has said that while in general he likes things to be "clean and neat," he also likes "dirty sinks, the soggy abandoned clothes I see in the alley behind my studio all the time, crusted dried pools of liquid and all the other picturesque things so akin to the spirit of photography."[31] By "the spirit of photography" he seems to mean the countless contingent–and in this case, base–details that can be scooped up by the camera. Yet, as the title *Diagonal Composition* makes clear, this subject is a vehicle less for social realism than for formal exploration, in the shape of intersecting angles and the different colors of worn-out Formica. Wall is explicit about his concerns:

28  Tillmans, in Obrist, *Wolfgang Tillmans*, 104.
29  John Szarkowski, *Winogrand: Figments from the Real World* (New York: The Museum of Modern Art, 1988), 36.

30  Ad Reinhardt, in his comic strip "How to Look at Space" (1946). See *How to Look: Ad Reinhardt Art Comics* (New York: David Zwirner, 2013), 31.
31  Jeff Wall, "A Note about Cleaning" (2000), in Theodora Vischer and Heidi Naef, eds., *Jeff Wall: Catalogue Raisonné, 1978–2004* (Basel, Switzerland: Schaulager, 2005), 393.

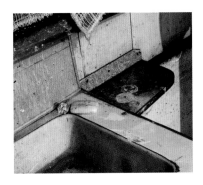  

*I like the composition of a picture, the dance of colours and shapes across it, more than I like the subject. I love whatever subject I'm working on at the time because it's taking me into the picture. When I'm done with the picture, I'm probably done with the subject. Some might say that's a bit hostile and bit detached. But I go with my impulses and it seems that the art of composition is a great art.*[32]

Wall is deliberately pushing back here against those who would interpret his work exclusively in terms of its subject matter. While his subjects clearly are of importance to him, the structural aspects of picture making are of great significance too. His work acknowledges the tension in the photographic image as a record of a particular moment, but which at the same time is part of a long tradition of picture making. Indeed, *Diagonal Composition* has already generated other works that are in dialogue with it, including Christopher Williams's *Untitled (Study in Yellow and Green/ East Berlin)*…(2012, see caption above for complete title). Williams's photograph shows a meticulous re-creation of a scene from the former East Germany, with wallpaper, sink, and soap all replicating East German products. Thomas Demand's *Daily #21* (2013) depicts the sink in Joseph Beuys's studio. Demand placed a bar of soap on the edge of the sink to make a deliberate reference to Wall's work.

In describing earlier photography as "ending up in a book," Wall was raising the question of how we experience photography. Until the late seventies, and even after, the photographs one normally saw exhibited in galleries and museums were black-and-white prints, usually a standard eight by ten inches. "Even while I loved photography," he wrote,

---

32  Wall, quoted in Ure-Smith, "New Artistic Directions for Photographer Jeff Wall in Amsterdam."

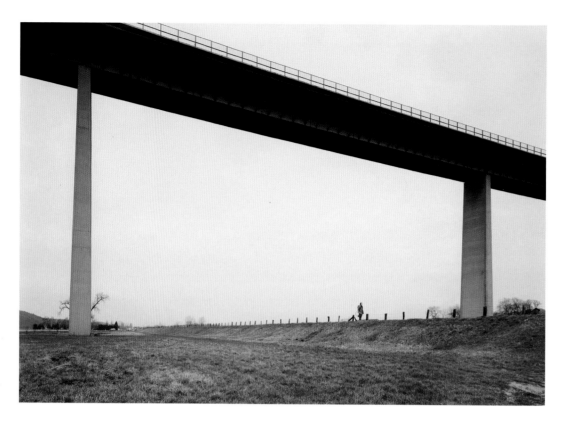

Andreas Gursky
*Ruhrtal*, 1989

*I often didn't love looking at photographs, particularly when they were hung on walls. I felt they were too small for that format and looked better when seen in books or leafed through in albums. I did love looking at paintings, though, particularly ones done on a scale large enough to be easily seen in a room. That sense of scale is something I believe is one of the most precious gifts given us by Western painting.[33]*

Beyond the compositional strategies available from painting in terms of structuring an image, then, the relatively new technical possibilities of making large, high-quality color prints also offered the possibility to challenge the physical presence of paintings in an exhibition context. The critic Jean-François Chevrier called this work "tableau" form, making the connection to painting explicit. "They are designed and produced for the wall," he wrote, "summoning a confrontational experience on the part of the spectator."[34] The fact that as late as 1989 Chevrier had to specify that he was discussing photographs made for the wall is in itself an indication of how unusual that idea still remained.

33  Wall, "Frames of Reference" (2003), in Vischer and Naef, *Jeff Wall: Catalogue Raisonné,* 444.

34  Jean-François Chevrier, "The Adventures of the Picture Form in the History of Photography" (1989), in Douglas Fogle, *The Last Picture Show: Artists Using Photography 1960–1982* (Minneapolis: Walker Art Center, 2003), 116.

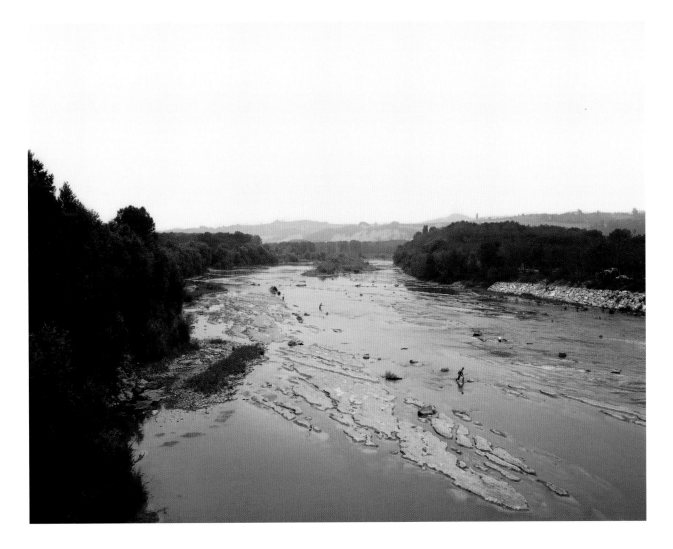

While a few artists had begun to make large-format photographs in the late seven-
ties, a more widespread leap in scale during the mid-eighties was the key to the decisive
entry of photography into the main exhibition spaces of museums. Thomas Ruff took the
portraits he had been making of his friends and acquaintances and reconfigured them from
a grid of small images to a series of enormous individual works, much larger than life size.
Andreas Gursky's *Alba* (1989), a sweeping river landscape in which we can see the relatively
tiny figures of a few men fishing, is nine feet wide, as big as any ambitious nineteenth-cen-
tury painting. Like Ruff, Gursky was one of the extraordinary generation of artists to
study with Bernd and Hilla Becher at the Düsseldorf Kunstakademie, but this work (made

Andreas Gursky
*Alba*, 1989

before Gursky began to make extensive use of digital technology in his pictures) feels like a turn away from their restrained typological approach in favor of a sublime and totalizing romanticism. The small scale of his figures, he has said, "indicate my interest in the human species as opposed to the individual."[35] In the context of his other photographs from the same period, however, which often show aspects of the industrial and commercial landscape, Gursky would no doubt see *Alba* as part of a broad continuum less connected with the Romantic tradition than it might at first appear, and the gray, cloudless sky above certainly recalls the Bechers' work. What is undeniable, however, is that pictures on this scale called for exhibition contexts comparable to those given to painting.

Barbara Probst's pictures force the implication of the viewer in the composition of the work, which can be fully experienced only in the context of the physical space in which it is displayed. She pairs two or more photographs of a single scene taken simultaneously by different cameras, so that there is a subtle difference between them that can be resolved only by an engaged viewer. As she puts it, "The images have a spatial relationship to each other, similar to the cameras that generated these images in the first place. And the viewer relates to this spatiality by moving within the space between the images while looking at them." This is work that requires the space of exhibition to be fully experienced. Probst considers the actual physical space between the work and those who look at it: "I always choose the size of the images in regard to their relationship with the viewer, so that he or she will need to move physically to view the whole work, be it only by turning the head or walking back and forth between the images."[36]

Since Probst's work almost always involves women looking or being looked at, the movement of the spectator to find the right positioning vis-à-vis the images on the wall also raises questions of social power that go beyond the photographs themselves. Speaking of double portraits such as *Exposure #70: Munich studio, 05.10.09, 3:03 p.m.* (2009), taken with two cameras positioned side by side, Probst says of her subjects:

> One looks into the camera on the left, and the other looks into the camera on the right, and that results in two images that look very similar but are very different, because the very neutral, emotionless expressions of the people portrayed produce different effects in each of the two images. Here the standpoint of the viewer is clearly disjointed: the subjects are gazing at him, and now he must actually decide where to look and from where to withdraw his gaze. The work, then, is not just about the viewer's standpoint but also about his gaze and his choice of where to look.[37]

35  Andreas Gursky, in Rudolf Schmitz, "Neither Murder nor Baptism: Andreas Gursky's Holistic View," trans. Ishbel Flett, in *Andreas Gursky: Photographs 1984–1993* (Hamburg: Deichtorhallen; and Amsterdam: De Appel, 1994), 11.

36  Barbara Probst, interview with Frederic Paul, in *Barbara Probst* (Ostfildern, Germany: Cantz, 2013), 146.
37  Probst, interview with Johannes Meinhardt, in *Barbara Probst: Exposures* (Göttingen: Steidl, 2007), n.p.

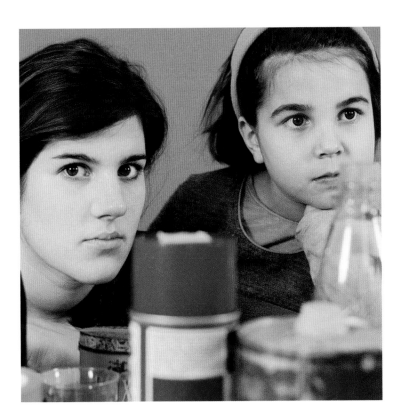
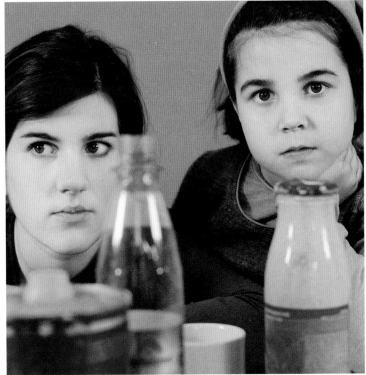

Barbara Probst
*Exposure #70: Munich studio, 05.10.09, 3:03 p.m.*, 2009

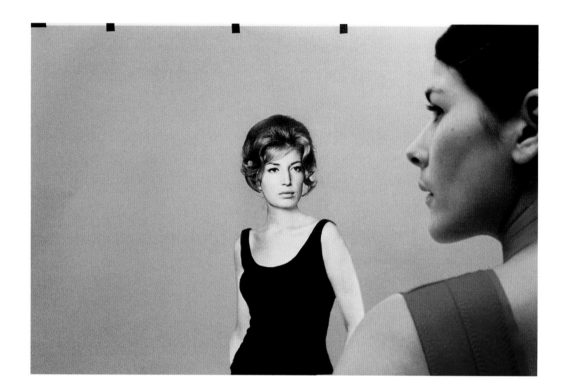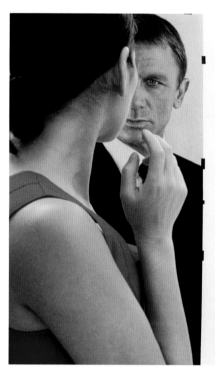

Barbara Probst
*Exposure #87: N.Y.C., 401 Broadway, 03.15.11, 4:22 p.m.*, 2011

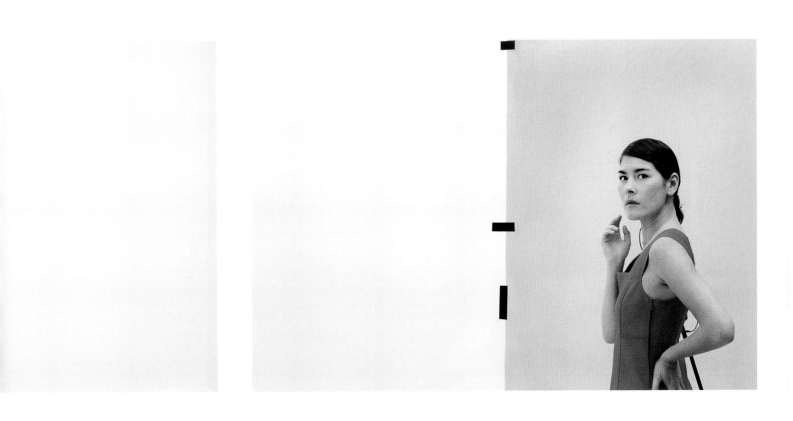

Ambiguity and uncertainty about where to look is compounded in *Exposure #87: N.Y.C., 401 Broadway, 03.15.11, 4:22 p.m.* (2011), in which images of film stars are folded into the triptych, creating a complex web of looking between the viewer and those depicted.

Probst's photographs are sometimes large, but not always. Work made for display on the wall need not be huge. While Christopher Williams, for example, certainly makes his work for the wall, he has always kept his photographs at a relatively modest scale, preferring instead to work with systems of display that are not dependent on the size of his images. Younger artists such as Annette Kelm and Elad Lassry have also kept their work relatively small. Space left around the work can contribute to a strong presence on the wall.

Kelm's photograph of a single acorn, placed carefully on a field of yellow, is a small photograph, but very clear in its compositional intentionality. The acorn might imply that it stands in for some future mighty oak tree, but for now we are asked to look only at the acorn. *First Picture for a Show*, the 2007 work is called, reinforcing the idea that the acorn is a starting point for future growth. Yet it is also a kind of degree zero picture: the minimum necessary for it to be a picture of anything at all, and at the same time a distilled version of what it represents. For Beatrix Ruf, Kelm's work is "the result of a constant back and forth between seeing and composing, followed by rejection and further composition. It is a process that is similar to painting. Kelm deliberately works with techniques reduced to the basics of photography; she borrows from painting the ambition of using simple means to produce individual images and portraits derived from the subjective perception of reality."[38] As Ruf indicates, no matter how simple *First Picture for a Show* might appear, it is unequivocally the result of an intense process of composition.

If Kelm's photograph represents a particularly minimal version of the composed image, we might consider Wall's *A view from an apartment*, photographed between June 2004 and March 2005, to be at the opposite extreme. Over eight feet wide, the back-lit transparency shows two young women in an apartment, one ironing and folding laundry, the other reading a magazine. The scale of the work means that they appear virtually life size, giving a great immediacy to the scene for the viewer. Especially compared with *First Picture for a Show*, this seems at first to be an image taken almost at random. It is full of quotidian detail. Wall actually had the woman on the left live in the apartment for almost a year before shooting the photograph, and she furnished it herself. But the work is nonetheless carefully composed; although the apartment

---

38   Beatrix Ruf, "Twisting and Turning," *Parkett*, no. 87 (2010): 156.

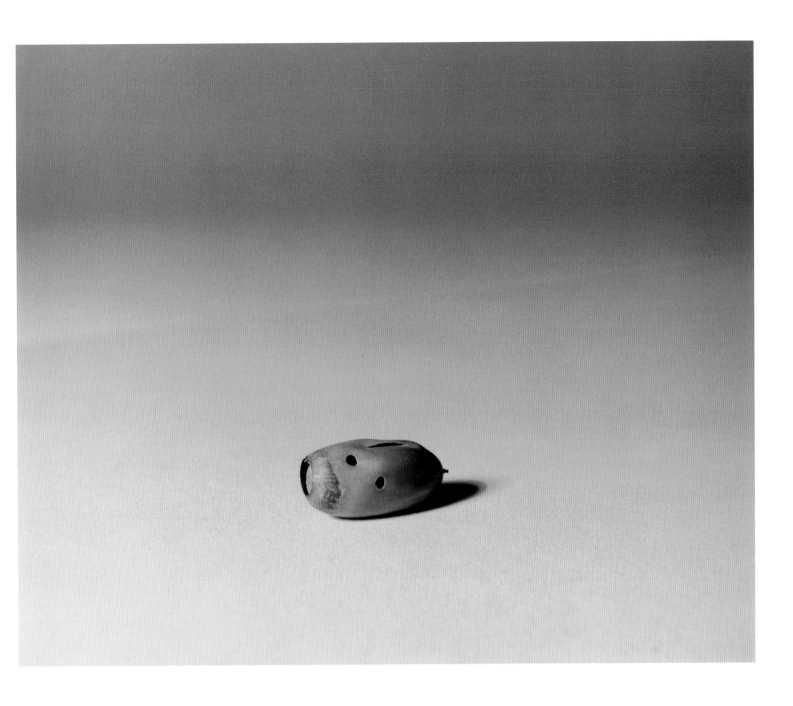

Annette Kelm
*First Picture for a Show*, 2007

Annette Kelm
Untitled, 2007

reflects the real life of its inhabitant, Wall made a number of adjustments to the scene to achieve the effects he wanted. ("Profiting by accident is very different from leaving every thing to accident," as the eighteenth-century theorist of the painterly picturesque Richard Payne Knight said.[39])

Wall's pictures are often structured by strong diagonals, and *A view from an apartment* is no exception. Beyond that framework, it also offers a multilayered play of pictorial elements. There are framed pictures on the wall, and a "picture window" offers an expansive view of the Vancouver waterfront. Indeed, the title suggests–disingenuously–that the real subject of the work is this view, even as the people in the room ignore it. A landscape is introduced into a genre scene, and not just figuratively. Because the interior was shot at dusk, the exterior landscape is literally inserted into the composition from another negative. Playing with the traditional concept of a painting as a window onto the world, Wall puts a window at the center of his composition, embedded in a quite different environment. The picturesque element–the harbor–is a straight  depiction of the landscape as it is (although Wall deliberately waited until winter to shoot) while the interior is painstakingly staged, but staged to represent a mundane everyday life. It draws not just from painting, of course, but also from the cinema. While the scale and the complex composition suggest painting, the implied ongoing narrative in the work simultaneously evokes a still from a movie. Both elements contribute to the overall effect, which oscillates between the staged and documentary elements. The extent to which *A view from an apartment* can even be called a "staged" photograph is ambiguous. While Wall put in place the overall situation, his representation of the activities of the women and their surroundings is close to documentary. Indeed, the fact that the work is a photograph makes it unavoidable that on one level at least we are simply seeing an indexical record of what was in front of the camera. "I reject the idea I'm doing 'staged photography,'" Wall says. "Every kind of behavior is equally real."[40]

The window motif that is so prominent in *A view from an apartment* has of course been a staple of pictorial discourse since the Renaissance, something Wall has recognized in the series Blind Windows, images of boarded-up or painted-over windows. Tillmans has also made use of the trope, albeit in a more directly documentary way. His *window New Inn Yard* (1997) uses the frame of a window to organize an image of further (opaque) windows set into an opposing brick wall. While Tillmans's image is found

39   Richard Payne Knight, *The Landscape* (London: Bulmer, 1794), 48.

40   Wall, interview with Andrew Pulver, "Photographer Jeff Wall's Best Shot," *Guardian*, May 5, 2010.

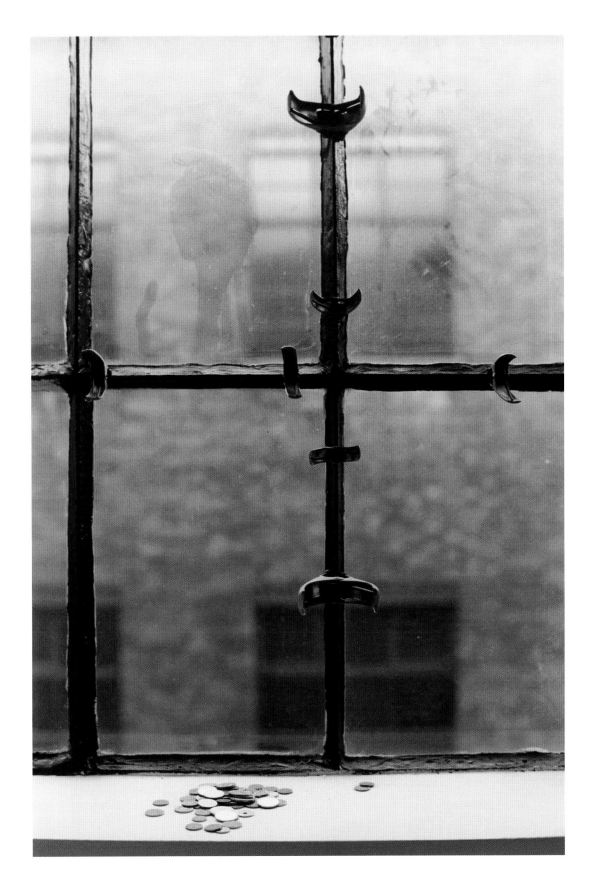

Wolfgang Tillmans
*window New Inn Yard*, 1997

Jeff Wall
*Blind Window no. 3*, 2000

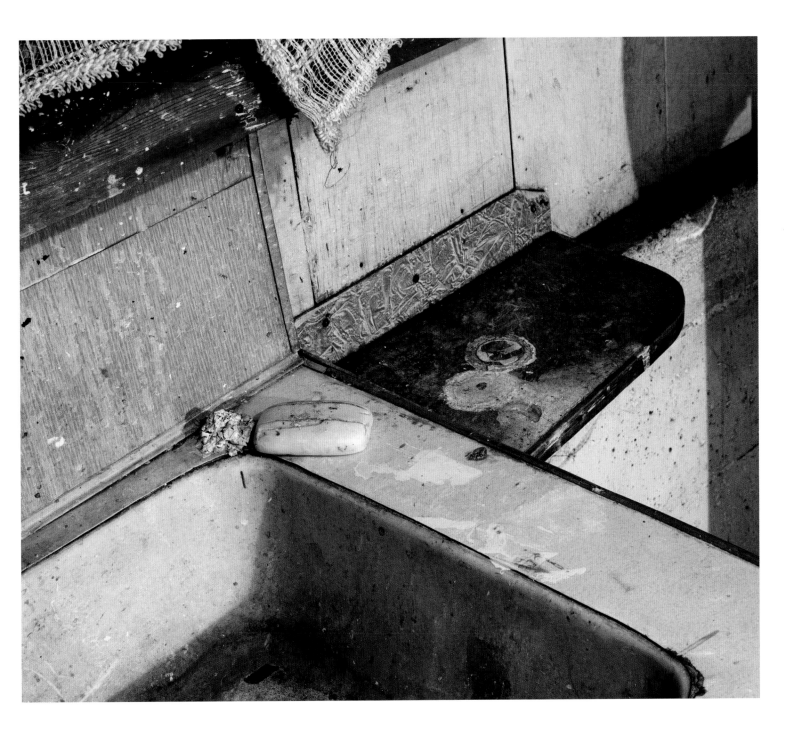

Jeff Wall
*Diagonal Composition*, 1993

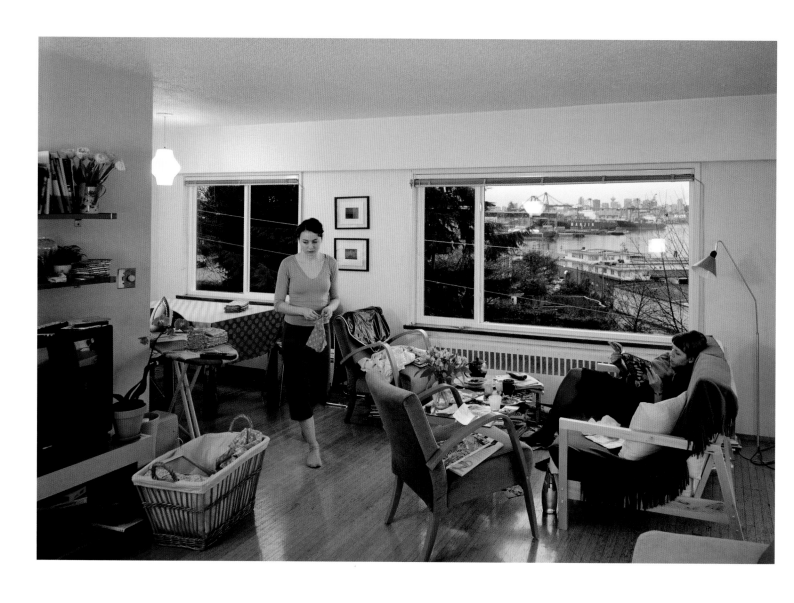

Jeff Wall
*A view from an apartment*, 2004–05

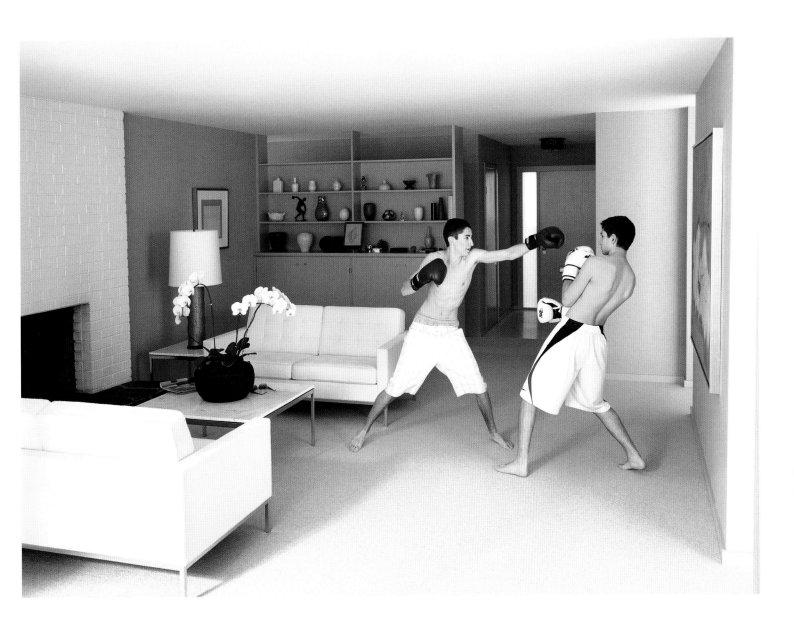

Jeff Wall
*Boxing*, 2011

rather than arranged, it is nevertheless decisively composed. The windowsill holds a scatter of loose change that takes up little space but anchors the picture as a whole. Tillmans is ambiguous about the whole project of representation, and in fact in recent years has been making more abstract, darkroom-based work. In his abstract work, he says, "I feel myself liberated from the obligation to represent–that compulsion to represent, that compulsion to make pictures, which has increased around us over the past twenty years."[41] Despite this stated discomfort with making pictures, however, his relatively early work such as *window New Inn Yard* displays the artist in complete control of a very simple but compelling pictorial composition. Nevertheless, he seeks to find a balance between his own decision making and the need not to overdirect: "I believe that, in our times, control is valued above passive acceptance. But I happen to regard these two stances as equally powerful."[42]

Rodney Graham's *Dead Flowers in My Studio* (2009), a large light box, is also in some ways a straightforward picture. At first it seems that it could not be more casual. A bunch of flowers and leaves, dead and dried out, rest in a vase, which sits on a table surrounded by a mess of paint and paintbrushes. After a moment's reflection, however, the picture reveals itself as part of a long-established allegorical tradition. It is a vanitas, a memento mori. A reminder, that is, that all living things must someday die. Perhaps more is dying here than the flowers. The studio is Graham's, but it is no photography studio. Paint is splattered all around, on the table and on the walls. Paintbrushes are everywhere, many of them in jars or other containers, echoing the dead flowers in their vase. Are the paintbrushes themselves vanitas emblems of a pictorial system rendered obsolete by photography? Graham does sometimes make paintings, and this studio can be associated with the series of "modern" works he exhibited in 2007 under the parodic title *Wet on Wet: My Late Early Styles (pt. 1: the Middle Period)*. But what we see here is as much a self-conscious representation of an artist's studio as a record of an actual workplace. In a double sense, it is a place to make a picture. So is his *Small Basement Camera Shop circa 1937* (2011, p. 6). This work, based on a found snapshot, features the artist himself as the figure behind the counter. If *Dead Flowers* is a memento mori for painting, perhaps it is also possible to see this Norman Rockwell–like scene as one for the pre-digital age of photography itself, when every small town had a camera shop like this.

41  Tillmans, in Obrist, *Wolfgang Tillmans*, 91.
42  Ibid., 103.

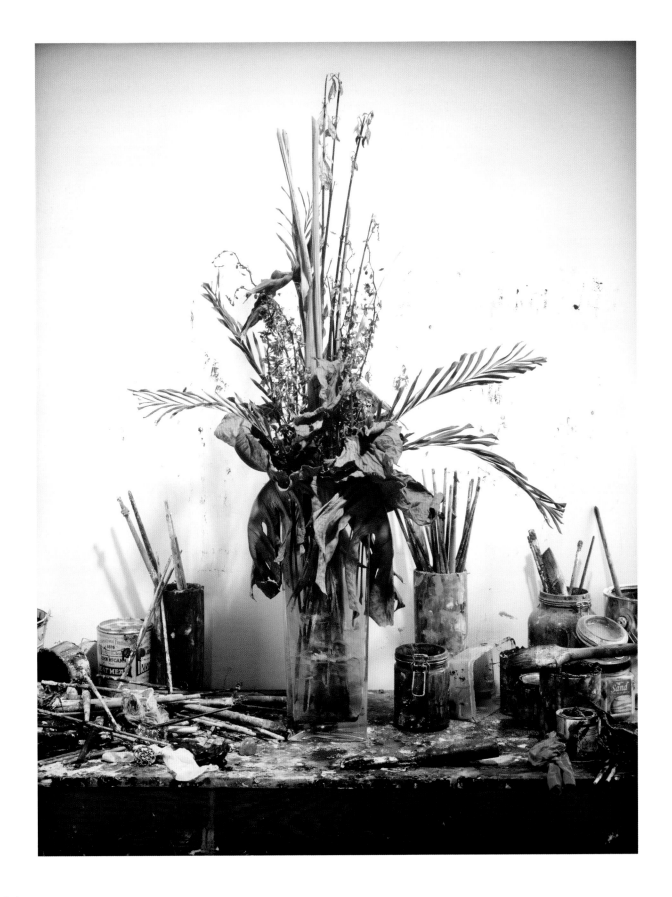

Rodney Graham
*Dead Flowers in My Studio*, 2009

The memorial aspect of Graham's dead flowers reminds us that from the beginning of photography–and still today–one of its most important functions has been to record the likenesses of those who have subsequently died. It is no accident that the portrait was the focal point of early photography, its fundamental claims to accuracy and authenticity making this one of the first areas in which it was to supplant painting. For Walter Benjamin, "The cult of remembrance of loved ones, absent or dead, offers a last refuge for the cult value of the picture. For the last time the aura emanates from the early photographs in the fleeting expression of a human face. This is what constitutes their melancholy, incomparable beauty."[43] This almost mystical sense of the photographic portrait as having a special aura is also what makes people sometimes reluctant to be photographed: the suspicion that the photograph might reveal too much. As Diane Arbus said, "there's a point between what you want people to know about you and what you can't help people knowing about you."[44]

But what if the photographer does not want to show what the subject might prefer to keep hidden? Ruff's iconic 1980s portraits of his friends and colleagues seem to draw equally from formal portraiture and from the most generic of identification cards. When he began to make these large-format prints in the mid-eighties, mounting them directly to Plexiglas, the size was highly unusual for any form of photography. The scale, far greater than life size, renders his subjects both totally present and yet also somehow inhuman. The even lighting, the straight-ahead positioning, and the sitters' lack of any overt expression or emotion combine to create a powerful presence, almost clinical, yet without appearing to seek any truth behind appearance. Ruff himself seems reluctant even to describe these works as portraits. As he has said, "I don't believe we can still make portraits in the conventional sense of 'representing a personality' today. At least I don't claim to do that. Which is why I imitate portraits."[45] The signifiers of the real challenge the documented reality. "It is no longer a question of imitation, nor duplication,

43  Walter Benjamin, "The Work of Art in the Age of Mechanical Reproduction" (1936), in *Illuminations*, trans. Harry Zohn (New York: Schocken, 1968), 226.
44  Diane Arbus, in *Diane Arbus* (New York: Aperture, 1972), 2.

45  Thomas Ruff, quoted in Thomas Weski, "The Scientific Artist," in *Thomas Ruff: Works 1979–2011* (Munich: Schirmer/Mosel, 2012), 26.

Thomas Ruff
*Porträt (P. Stadtbäumer)*, 1988

Thomas Ruff
*Porträt (H. Hausmann)*, 1988

Thomas Ruff
*Porträt (E. Denda)*, 1989

nor even parody," as Jean Baudrillard wrote. "It is a question of substituting the signs of the real for the real."[46] But in the end the very facticity of Ruff's subjects, drawn from his friends and acquaintances, eventually tends to push back against the opaque affect of the work. Okwui Enwezor, for example, has questioned the neutrality that is often ascribed to the series, arguing that "in the social and racial uniformity of the sitters could be read the deadly homogeneity of an isolated culture."[47] Photography's inherent specificity can make even work that strives for the generic into a social document.

For Michael Clegg and Martin Guttmann the portrait retains its fascination but at the same time seems almost emptied out of new possibilities. "The idea of pose has been a constant preoccupation," they say. "But we don't have a theory of pose, rather our assumption is that by the late twentieth century it's impossible to invent new poses. The variables of 'quiet' poses are few and virtually everything you come up with is saturated with prior meaning." Clegg & Guttmann want to drain their work of the idea that the personality of their subject might be revealed: "The notion of self-presentation is thus denied a 'psychology,' as it is performed and received according to preexisting parameters."[48] *Grand Master* (1982) makes use of the dark background associated with old master paintings as well as dramatically strong side lighting to create an image that participates in many conventions of the portrait. The fact that the gloomy and austere architectural setting–the library at Columbia University–is an evident backdrop, and that the subject is an actor–Bill Rice, a frequent model for the artists–only emphasizes the degree to which their real interest is in the codes of power and their pictorial representation. "Using actors initially was very important," they say, "since it made our intentions clearer, this was an image about the way power represents itself, it was a simulation of a commission."[49]

46  Jean Baudrillard, "The Precession of Simulacra," in *Simulacra and Simulation*, trans. Sheila Faria Glaser (Ann Arbor: University of Michigan Press, 1994), 2.
47  Okwui Enwezor, "The Conditions of Spectrality and Spectatorship in Thomas Ruff's Photographs," in *Thomas Ruff: Works 1979–2011*, 13.

48  Clegg & Guttmann, interview in *Clegg & Guttmann–Portraits de groupes de 1980 à 1989* (Bordeaux: CAPC, 1989); reprinted in *Clegg & Guttmann: Modalities of Portraiture* (Zürich: Codax, 2013), 80.
49  Clegg & Guttmann, "Capitalism and Portraiture," interview with Oliver Koerner von Gustorf, in *Clegg and Guttmann: Portraits and Other Cognitive Exercises, 2001–2012* (Vienna: BAWAG, 2012), 31.

Clegg & Guttmann
*Grand Master*, 1982

Catherine Opie's two 2012 portraits of the artist Lawrence Weiner at first resemble those made by Clegg & Guttmann in their dark backgrounds that evoke Rembrandt and other old masters, and in the formal half-length presentation of the sitter. But unlike those artists, Opie is very much interested in the psychology of the sitter as well as the formal aspects of her composition. "I liked the vulnerability in his body,"[50] she says of Weiner, and she emphasizes it with a traditional symbol of transience, the smoke that drifts upward from his cigarette. Of her portraits in general, she has said that "even though I don't believe that there is a true essence of a person, I do believe that there is something that they see within themselves that I end up capturing."[51]

Andres Serrano's *Klansman (Imperial Wizard III)* (1990) is a portrait that shows a lot about its subject even though his face is almost completely hidden by his hood. It is part of a series that Serrano made at some risk during the national controversy occasioned by his *Piss Christ* (1987). In formal terms the green hood stands out graphically against a black background, its right side deeply shadowed. We cannot, of course, see the face. We can almost see a single eye peering out from inside the crudely stitched hood. An ordinary person is using the costume to be transformed into something he believes to be greater than himself; he becomes an Imperial Wizard of the Ku Klux Klan. But the Imperial Wizard seems somewhat less terrifying than he might wish to be. "I realized that they become more powerful as symbols than they actually were as human beings," Serrano says of the Klansmen he photographed. "I saw them as human beings first, and then they put on their robes and became symbols."[52] Serrano has found something sad and needy in his subject, something the Wizard can't completely conceal, in an image that conceals almost every aspect of its subject. *Klansman* is a deeply penetrating portrait, predicated on refusing almost everything we expect in a portrait.

50   Catherine Opie, e-mail to the author, January 16, 2015.

51   Opie, interview with the author (1996), in *Catherine Opie: American Photographer* (New York: Guggenheim, 2008), 104.

52   Andres Serrano, interview with Coco Fusco (1991), in Fusco, *English Is Broken Here* (New York: New Press, 1995), 85.

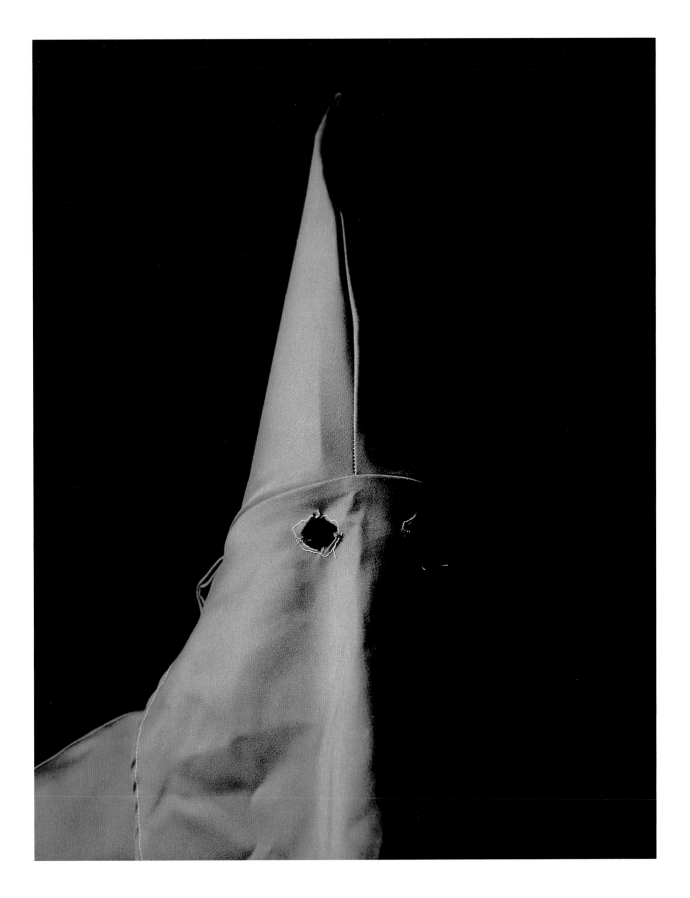

Andres Serrano
*Klansman (Imperial Wizard III)*, 1990

Catherine Opie
*Lawrence*, 2012

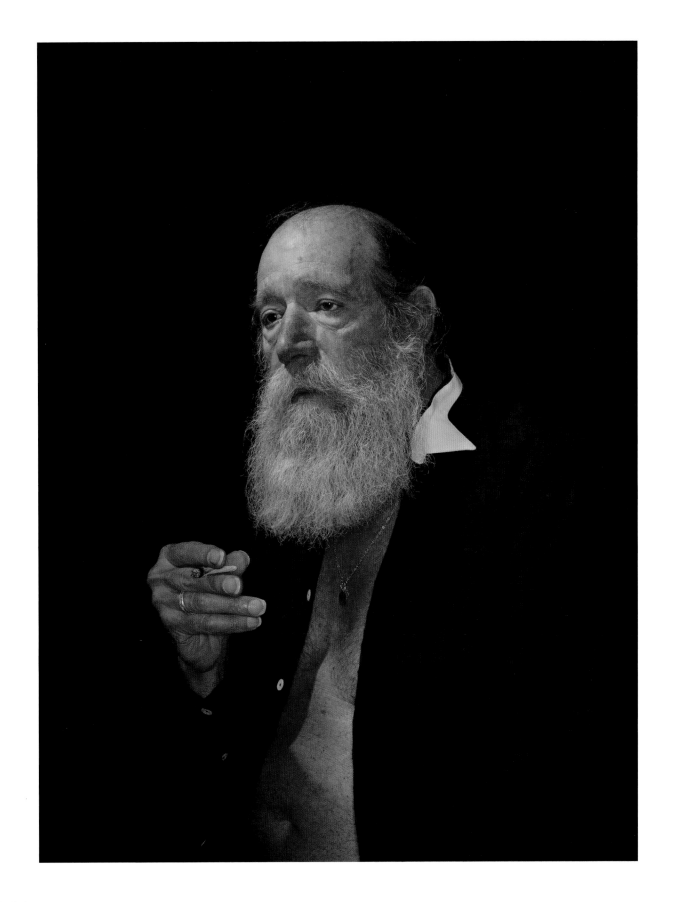

Catherine Opie
*Lawrence (Black Shirt)*, 2012

In Gillian Wearing's 2003 self-portraits as her mother and her father, the eyes are again the only part of the artist's face that we truly see, the rest being latex masks made based on family photographs. These pictures do not, of course, have the politically loaded quality of Serrano's photographs of Klansmen, but in their intense psychological ambiguity they are equally disturbing. Wearing's eyes look out, literally, from behind a mask, and viewers are left to fill in what it might mean to appear in this way reinscribed into one's family history. "You always feel that you are the mask to some degree," she has said. "The photo of my mum I used was from before I was born, when she was twenty-three. She was this quite innocent, optimistic young woman, I think. You are trying to get that across, somehow. I mean, my eyes are the only thing I have to use, but I try to make them as hopeful and young as possible."[53]

Sharon Lockhart's *Goshogaoka Girls Basketball Team* (1997) shows Japanese suburban middle-school girls fully inhabiting the roles defined for them by their membership in the team. In these carefully choreographed portraits, made in conjunction with Lockhart's film *Goshogaoka* (1997), the girls hold poses that suggest the action of a game, although no ball is visible. On one level the pictures suggest publicity images for professional athletes, yet the girls' youth undercuts that implication. Lockhart's interest is in the pose itself. It is a pictorial sensibility that runs through much of her work, even in less overtly staged works such as Untitled (2010), in which we see a woman working on a jigsaw puzzle (that is, making a picture). In totally different ways Serrano, Wearing, and Lockhart challenge the traditional portrait by emphasizing concealment, collective identity, and a uniformity through which individual identity has to push.

Perhaps no artist working with photography has tried to neutralize specificity more completely than Demand, and perhaps no artist working with photography more literally "makes" a picture than he does. His desire for complete control over his images has led him to construct in three dimensions, out of paper and cardboard, exactly what he wants in his photograph, omitting any extraneous details. There are never any people in them (which suggests a link with the earliest days of photography, when the inability of the apparatus to capture any movement resulted in universally unpopulated

53   Gillian Wearing, in Tim Adams, "Gillian Wearing,"
*Observer*, March 4, 2012.

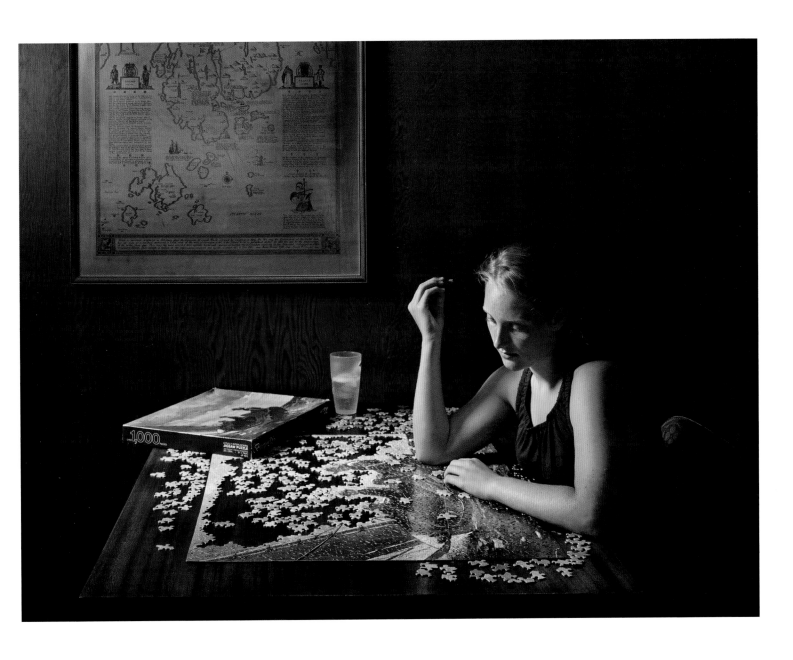

Sharon Lockhart
Untitled, 2010

Gillian Wearing
*Self-Portrait as my Mother, Jean Gregory*, 2003

Gillian Wearing
*Self-Portrait as my Father, Brian Wearing*, 2003

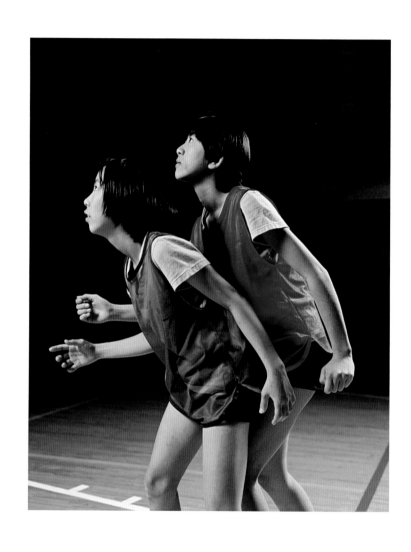

Sharon Lockhart
*Goshogaoka Girls Basketball Team: Kumi Nanjo
and Marie Komuro; Rie Ouchi; Atsuko Shinkai, Eri Kobayashi
and Naomi Hasegawa*, 1997

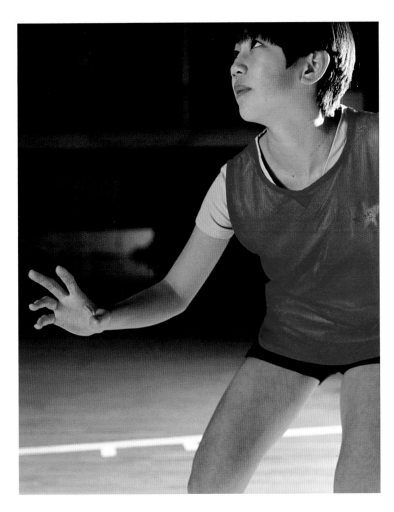
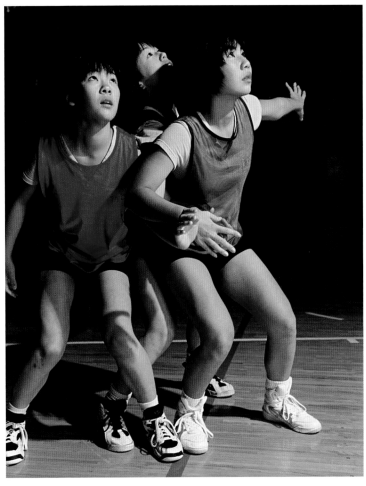

city streets). Specific signage, indeed any trace of language, is also excluded. This technique gives his work an uncanny quality. There is an underlying realization that the whole thing is made of construction paper; it could be swept away in a moment. We are clearly looking at photographs and can recognize the subjects, but in the end, in a work such as *Diving Board (Sprungturm)* (1994) we are seeing the Platonic essence of a diving board as much as any specific board, although it is also unequivocally a specific board. While in many of Demand's works the subjects of his images are historically or politically charged places, in this case the reference is more personal: the diving board is one he was too afraid to jump from as a child.[54] *Diving Board* is also one of a few early works in which the model was not made life size. At a certain point it became essential to Demand that the scale of what was photographed be identical to the original referent.

For Demand, the question of composition links his works specifically to painting: "You might say that the pictures I create are more like paintings than sculptures or photos, because they have a control over the pictorial space, like a painting that extends right out to all corners of the canvas. My pictures attempt to do that."[55] Demand's process of taking away the nonessential is also, literally, a process of construction that simultaneously asserts the control of the artist over every detail. Most recently, his choice of motifs has begun to include minimal still lifes drawn from everyday life. In the end the entire process of finding a resonant image, its painstaking (re)construction as a model, and its conversion into a two-dimensional image fall away to leave a picture and only a picture. His Dailies–images of clothespins, leaves, saucers, and rubber bands–are striking in the degree to which he can remove all hints of larger significance that attach to many of his earlier works and still make pictures that suggest an entirely remade world under the artist's control. For Michael Fried, Demand

> *aims to replace the original scene of evidentiary traces and marks of human use…with a counter-image of* sheer artistic intention, *as though the very bizarreness of the fact that the places and objects in the photographs, despite their initial* appearance *of quotidian "reality," have all been constructed by the artist throws into conceptual relief the determining force–also the inscrutability, one might say the opacity–of the intentions behind them.*[56]

54  Thomas Demand, conversation with the author, January 24, 2015.
55  Demand, "Thomas Demand: Constructing the Authentic," video interview, Louisiana Channel, available at http://channel.louisiana.dk/video/thomas-demand-constructing-authentic.

56  Michael Fried, *Why Photography Matters as Art as Never Before* (New Haven, CT: Yale University Press, 2008), 271. Emphasis Fried's.

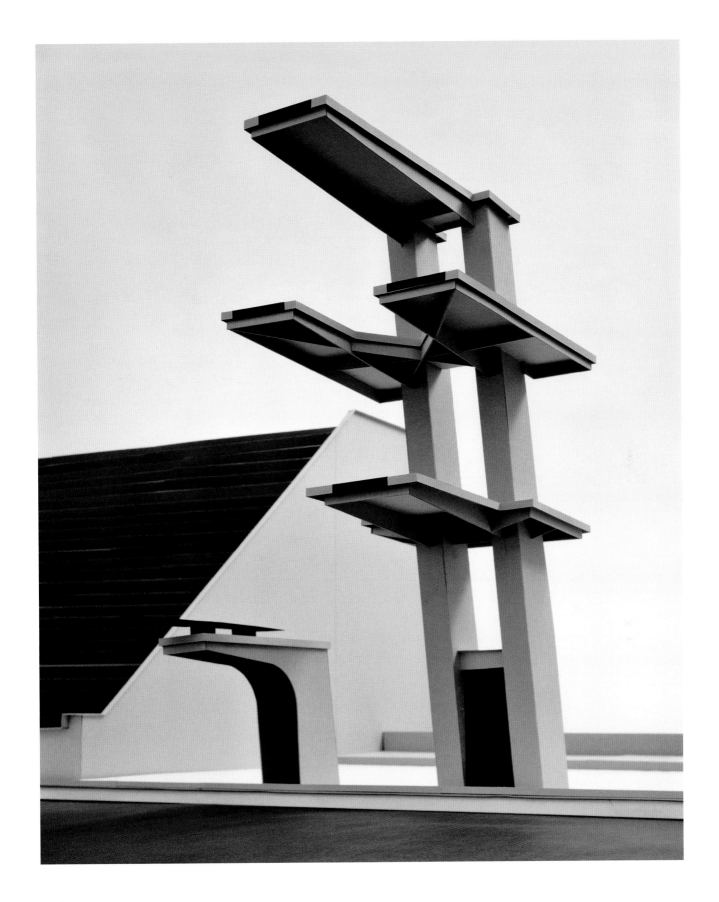

Thomas Demand
*Diving Board (Sprungturm)*, 1994

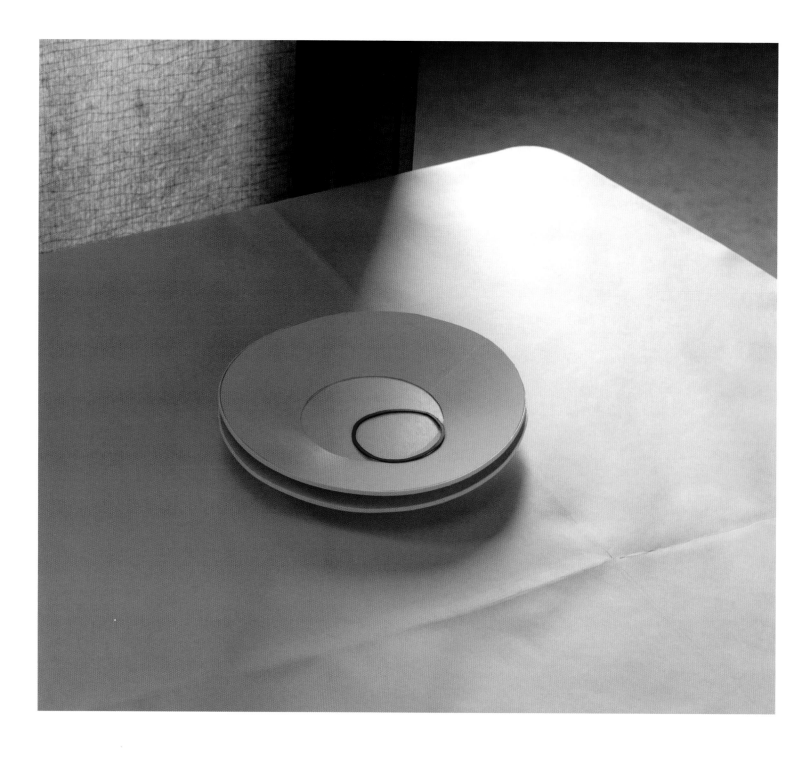

Thomas Demand
*Daily #13*, 2011

Thomas Demand
*Daily #14*, 2011

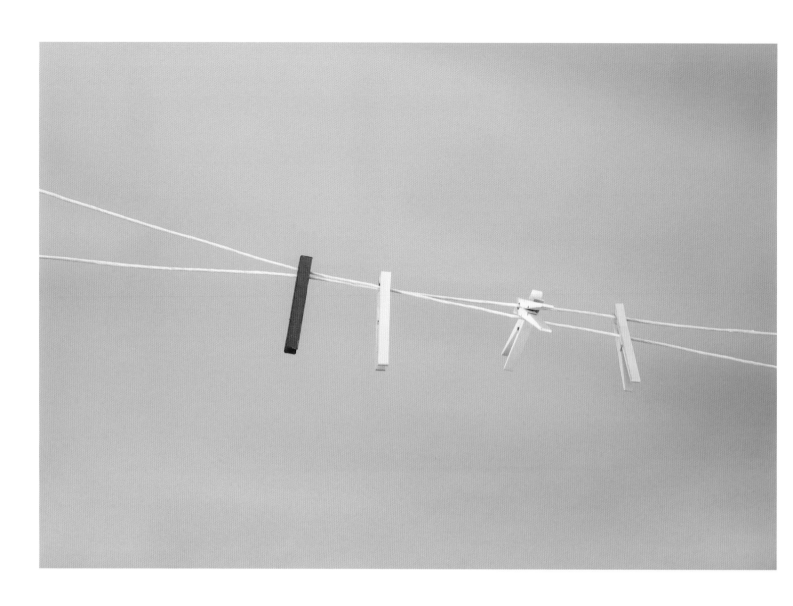

Thomas Demand
*Daily #17*, 2011

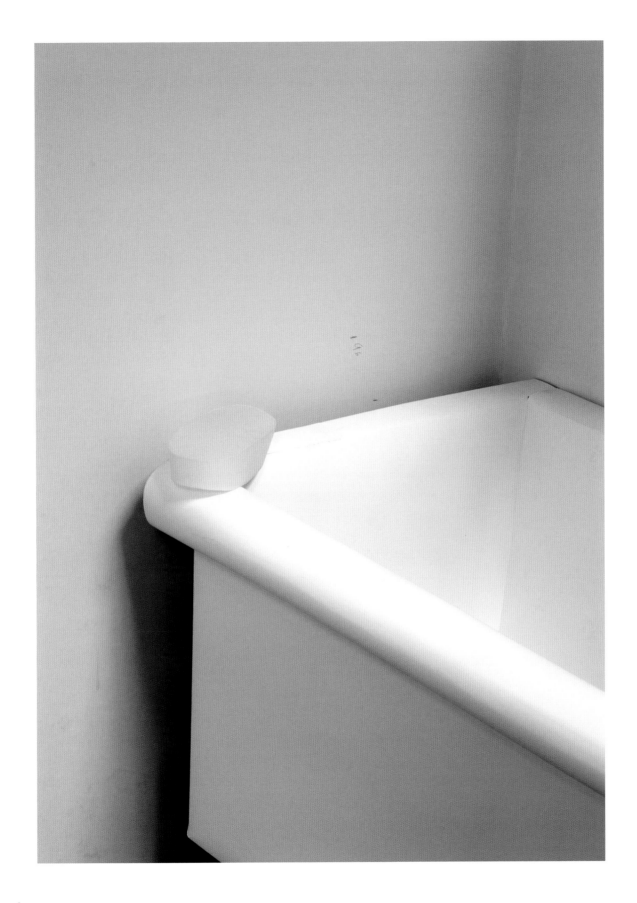

Thomas Demand
*Daily #21*, 2013

To retain this effect of strong intentionality, it is important that Demand's works not be digitally altered. Even as his way of working pulls the viewer away from the supposed reality of a given scene, the reality of what the viewer *is* given has to be unquestioned. "I cannot explain the world to you," Demand says. "I show you a picture."[57]

Like Demand, Florian Maier-Aichen's goal is the realization of a version of reality that conforms to his intentions. In his case, however, the tools of digital manipulation are central to his practice. "For many years," he says, "I always wanted to make my own pictures and not rely so fully on the world outside."[58] For an earlier generation of photographers, this assertion would seem borderline absurd. How could one make one's own pictures without engaging directly with the world? Maier-Aichen's description of making his *La Brea Avenue in the Snow* (2011), however, is almost a catalogue of steps taken to drain the real-world content from his image, starting with the conceit of making a snowscape in a city where it never snows: "I was looking at the stereotypical Becher images and their very moody skies. The [original] image was taken on a rare rainy day and I drew in the snow on the computer and tried to make the piece more 'timeless' by adding 'period' cars from the 70s to the 90s."[59] So he took as a model quintessentially German, conceptual, documentary photography, transferred it to Los Angeles, "drew" in nonexistent snow, and then drained even period specificity from the result by adding cars from different decades. In a way the work recalls a famous–painted–mural by the Los Angeles Fine Arts Squad, *Venice in the Snow* (1970), but the lingering color of authenticity that still attaches to photography makes Maier-Aichen's image more convincing, even for those of us who know that there is never snow on La Brea Avenue.[60]

The Los Angeles Fine Arts Squad
*Venice in the Snow*, June–November 1970

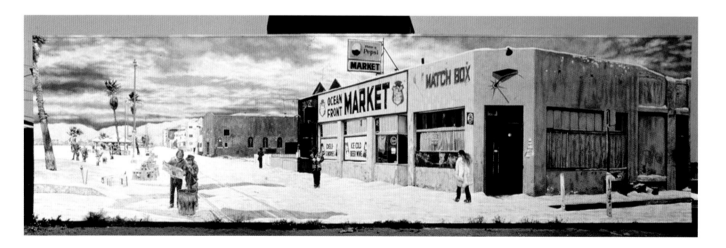

57  Demand, "Thomas Demand: Constructing the Authentic."

58  Tim Gardner, interview with Florian Maier-Aichen, *Art in America* online, May 11, 2011, available at http://www.artinamericamagazine.com/news-features/ interviews tim-gardner-interviews-florian-maier-aichen/.

59  Ibid.

60  For an early study of the impact of digital manipulation, see William J. Mitchell, *The Reconfigured Eye: Visual Truth in the Post-Photographic Era* (Cambridge, MA: MIT Press, 1992).

Florian Maier-Aichen
*La Brea Avenue in the Snow*, 2011

Lucas Blalock
*Both Chairs in CW's Living
Room*, 2012

For Lucas Blalock, the tools of digital manipulation exist on an equal plane to the release of the shutter. What was once the defining moment of photography is now one stage on the way to the final image. Rather than using these tools to create deceiving effects, however, Blalock deliberately uses them in a rough, unconcealed way. They are part of his picture-making process as much as a visible brushstroke might be in a painting. *Broken Composition* (2011) at first seems to be an image of two broken lightbulbs. In fact there was only one lightbulb, a decorative stained-glass one from Home Depot, and the doubling effect is produced by the repetition of the original image; the overlap is visible in the center of the image. As Blalock points out, "The title is a nod to this break as well as the more evident one."[61]

61   Lucas Blalock, e-mail to the author, January 9, 2015.

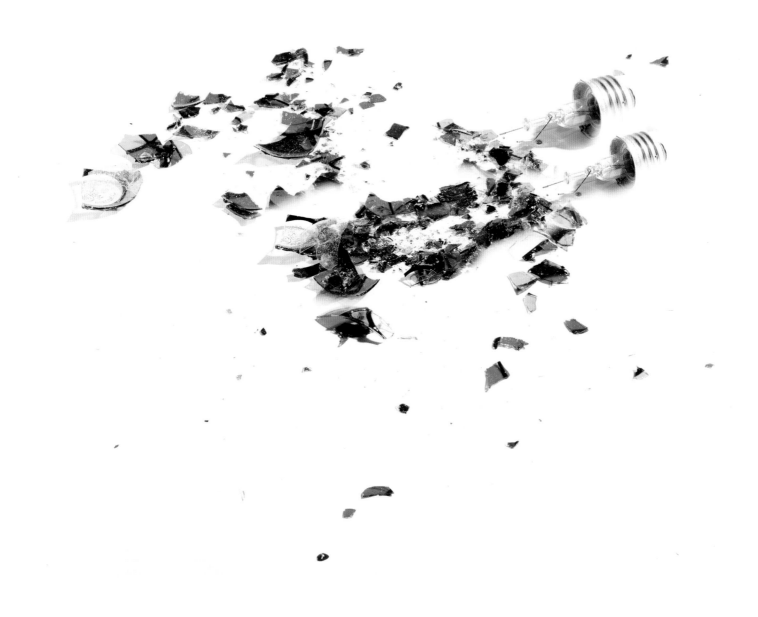

Lucas Blalock
*Broken Composition*, 2011

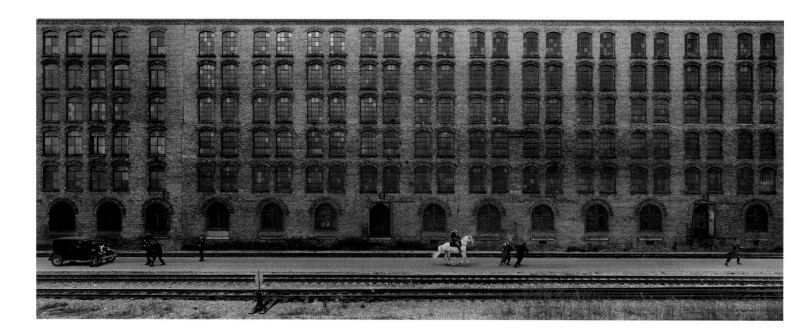

Stan Douglas
*Ballantyne Pier,*
*18 June 1935,* 2008

Even more than the use of Photoshop and similar programs, which do after all have antecedents in older techniques such as hand retouching, the representation of the past in photography runs directly counter to the mainstream emphasis on recording the world as it is *now*, at the instant of the shutter release, right in front of the photographer's lens. To represent the past marks a giant step away from the rhetoric of the camera as a uniquely authentic witness. Stan Douglas's *Hastings Park, 16 July 1955* (2008), one of a series of four photographs called Crowds and Riots, is a huge photograph that could not have been made in the period depicted. It shows a crowd at a racetrack in Vancouver, assembled by the artist from many different shots to create an apparently unposed but in fact carefully composed image. Each of the works in the series shows a moment from the history of life in Vancouver. *Hastings Park* is the least overtly political of these, but like the others its assemblage construction shows the point at which individuals coalesce into a group. Douglas's way of working clearly has a cinematic element, and his goal seems to be not so much to convince us that this is exactly how the past looked but to invite the viewer to think about history. As David Campany has written, "The stillness and pictorial artifice serve to *signal* the past rather than summon it forth as authoritative spectacle."[62]

62   David Campany, "The Angel of History in the Age of the Internet," in *Stan Douglas: Mise en scène* (Munich: Haus der Kunst and Prestel, 2014), 13.

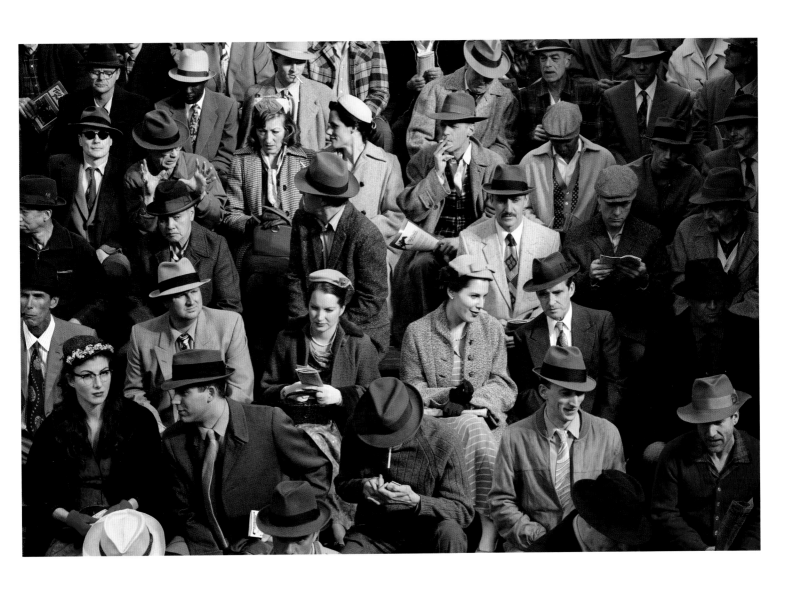

Stan Douglas
*Hastings Park, 16 July 1955*, 2008

David McDermott and Peter McGough's work extends far beyond photography, but they have made an imagined history a key element in all of it, to the extent that since the early eighties they have dressed and lived full time as if from various other eras, sometimes going as far as to remove plumbing from their homes or travel by horse and buggy. *Those Moments, 1955* (2010) shows an aesthetic tabletop arrangement characteristic of a studio setup from the period specified in the title. Despite the almost obsessive attention to detail in all of their work, it is always the aesthetic element that dominates. "I think beauty on its own is enough," McGough has said. "People always told us we lived in a fantasy, in a bubble, but the world is a very harsh place."[63] The kind of approach reflected in *Those Moments* self-consciously occupies a place rather close to the commercial product shot that largely took over the territory of the straightforward still life in the first half of the twentieth century. That closeness to the commercial world is another of the tacit taboos that art photography has observed, albeit often in the breach.

As early as the 1930s Walter Benjamin felt that photography already ran an enormous risk by acceding to its own capacity to render things in purely aesthetic terms. The risk was the danger of losing a relationship to the reality depicted. For Benjamin, photography could

*no longer depict a tenement block or a refuse heap without transforming it. It goes without saying that photography is unable to say anything about a power station or a cable factory other than this: what a beautiful world!* A Beautiful World–*that is the title of the well-known picture anthology by [Albert] Renger-Patzsch…. it has succeeded in transforming even abject poverty, by recording it in a fashionably perfected manner, into an object of enjoyment.*

The photograph could have no meaning without the accompanying information that would give the image a function, especially a political function. "What we require of the photographer is the ability to give his picture the caption that wrenches it from modish commerce and gives it a revolutionary useful value."[64]

While other, unique works of art might retain a certain aura, photography must be paired with language in order to avoid the trap of aestheticism or the service of advertising, a potential conflict recognized from the moment newspapers and magazines could easily reproduce photographic images. Benjamin's hostility toward the work of

63   Peter McGough, in Penelope Green, "Living in Sepia," *New York Times*, January 31, 2013, D1.

64   Walter Benjamin, "The Author as Producer" (1934), in *Reflections*, trans. Edmund Jephcott (New York: Schocken, 1978), 230.

McDermott & McGough
*Those Moments, 1955*, 2010

Albert Renger-Patzsch
*Iron Hand, Essen*, 1929

Renger-Patzsch—a member of the movement known as the Neue Sachlichkeit—comes in part from the title the latter's publisher gave his 1928 book—*Die Welt ist schön*—which does suggest a sunnier perspective than the actual photographs might indicate. For Benjamin, the title "unmasked the posture of a photography that can endow any soup can with cosmic significance but cannot grasp a single one of the human connections in which it exists."[65] Renger-Patzsch's work is in fact quite cool and analytical—objective, even, as *Sachlichkeit* is usually translated—although it is certainly beautiful too.

Christopher Williams's diptych of the Department of Water and Power building in Los Angeles brings together the two elements of Benjamin's analysis. These works are part of the series named For Example: Die Welt ist schön, an explicit reference to Renger-Patzsch.[66] There are, of course, great differences from Renger-Patzsch's work. The German worked systematically through a set of subject categories. Williams adopts an *apparently* systematic approach, but in practice he is highly discursive, even digressive. Information and references of all sorts flow into the work, without always being visible to the viewer. The results are images that seem to be highly objective but are nestled in a dense, sometimes impenetrable, web of references. The full title reads:

*Department of Water and Power*
*General Office Building, dedicated*
*on June 1, 1965*
*Albert C. Martin and Associates*
*May 18, 1994*
*(Nr. 1 and Nr. 2)*

While this is a relatively concise title in comparison to other works by the artist, it nonetheless seems to address Benjamin's demand for concrete information by precisely identifying the building depicted, when it opened, the architect who designed it, and when the photograph itself was made. "For all of the textual apparatus that accompany Williams's images," Alex Klein has written, "his viewers are nevertheless left with a catalogue of factual information that conveys little about the modes of production and systems of exploitation and consumption behind the objects depicted. Ultimately, the

65  Benjamin, "Little History of Photography" (1931), in *Selected Writings, Vol. 2, Part 2: 1931–1934*, eds. Michael W. Jennings, Gary Smith, and Howard Eiland (Cambridge, England: Belknap, 2005), 526.

66  See *Christopher Williams 97: For Example: Die Welt ist schön (Final Draft)* (Rotterdam: Museum Boijmans Van Beuningen; and Basel: Kunsthalle, 1997).

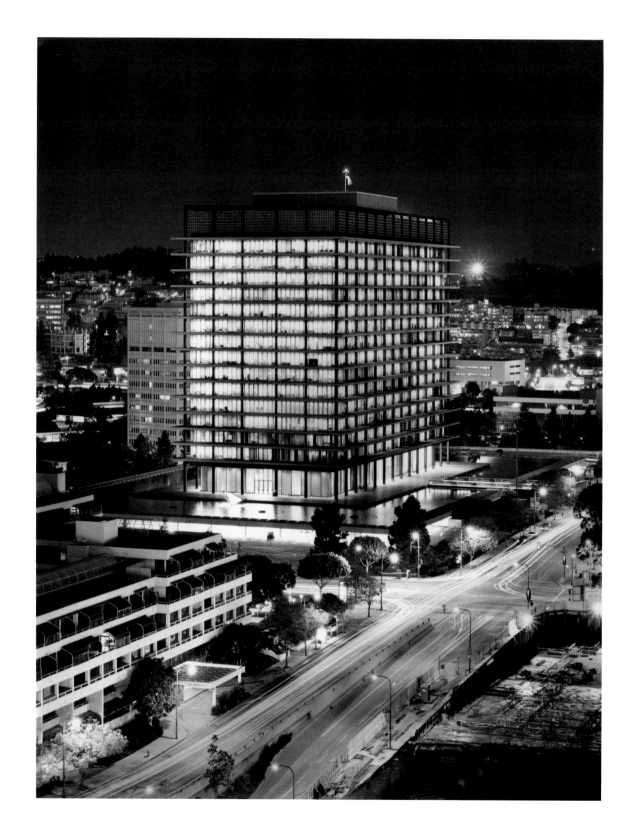

Christopher Williams
*Department of Water and Power*
*General Office Building, dedicated*
*on June 1, 1965*
*Albert C. Martin and Associates*
*May 18, 1994*
*(Nr. 1 and Nr. 2), 1994*

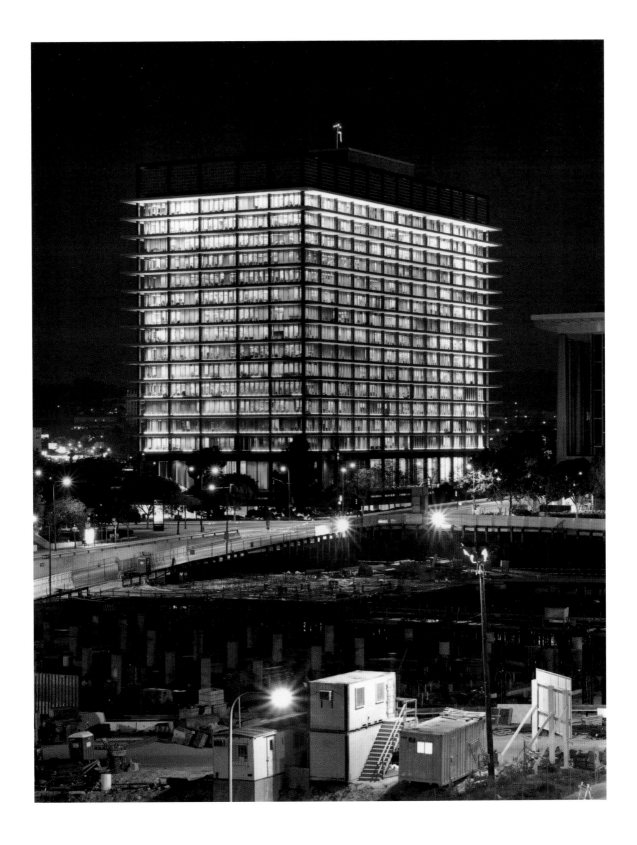

Christopher Williams
*Interflug Model: Iljuschin IL-62*
*Flight number: IF 882*
*Departure: 3:30 pm, SXF – Berlin Schönefeld, Berlin, German Democratic Republic*
*Arrival: 5:40 pm, ALG – Houari Boumediene Airport, Algiers, Algeria*
*Sunday, August 28, 1983*
*Studio Rhein Verlag, Düsseldorf*
*October 21, 2013,* 2014

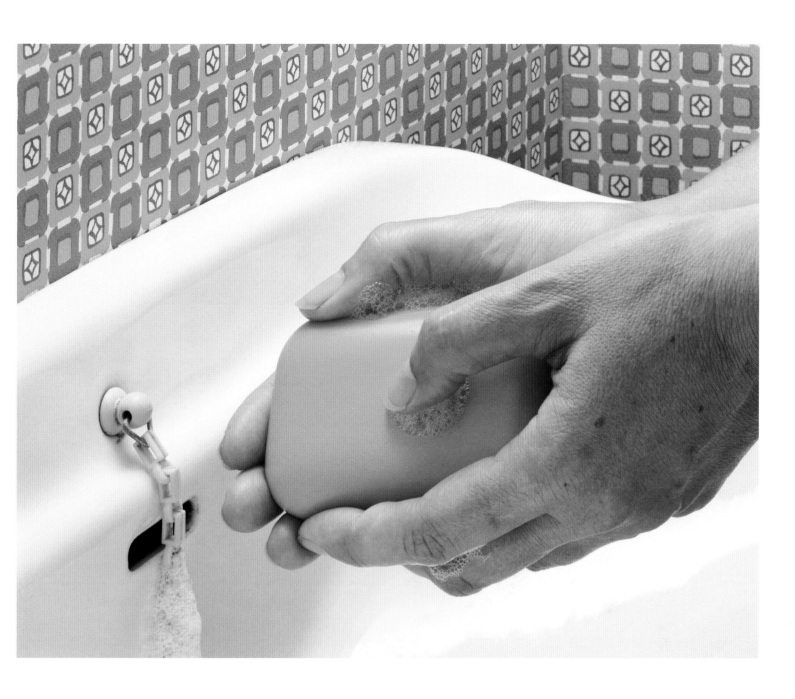

Christopher Williams
*Untitled (Study in Yellow and Green/East Berlin)*
*Studio Thomas Borho, Düsseldorf, July 7th, 2012*, 2012

Harun Farocki
Film stills from *Ein Bild*
*(An Image)*, 1983

photograph withholds meaning even as it discloses itself entirely."[67] Williams himself disputes the suggestion that his work is deliberately opaque while acknowledging, like an older generation of conceptual artists, that he does have a great interest in "the idea of disarticulation and methodologies of separation,"[68] an interest often manifest in various interventions into art institutions and their conventions of display.

As an example of the range of references that Williams packs into any apparently straightforward image, consider his account of *TecTake Luxus Strandkorb…* (2013):

> *In my photo of Zimra Geurts, who was the* Playboy *Netherlands Playmate of the Year in 2012, there are references to Guy Debord's* Society of the Spectacle, *in which automobiles, women in bikinis, and topless models appear; as well as references to Harun Farocki's film* Ein Bild, *which is about a* Playboy *centerfold shoot in Munich in the 1970s. Farocki's film is really about the labor that goes into constructing an image, in that case one associated with male pleasure. The diagonal strip that says "Balcar" is a representation of the soft box light that was used in the Farocki film. Of course the stripes on the* strandkorb konsul *[beach chair] relate to the artist Daniel Buren. So what comes together in this picture is a montage of several elements:* Playboy, *Buren, Debord, and Farocki.*[69]

Even apparently simple images such as *Untitled (Study in Yellow and Green/East Berlin)…* (2012) or *Interflug Model: Iljuschin IL-62…* (2014, see p. 119 for full titles of both) have comparable densities of information and reference folded into them.

67  Alex Klein, "Remembering and Forgetting Conceptual Art," in *Words without Pictures*, 127.

68  Williams, in conversation with David Andrew Tasman and Catherine Taft, "Christopher Williams: The 19th Draft," dismagazine.com, 2014, available at http://dismagazine.com/discussion/69719/christopher-williams-the-19th-draft/.
69  Ibid.

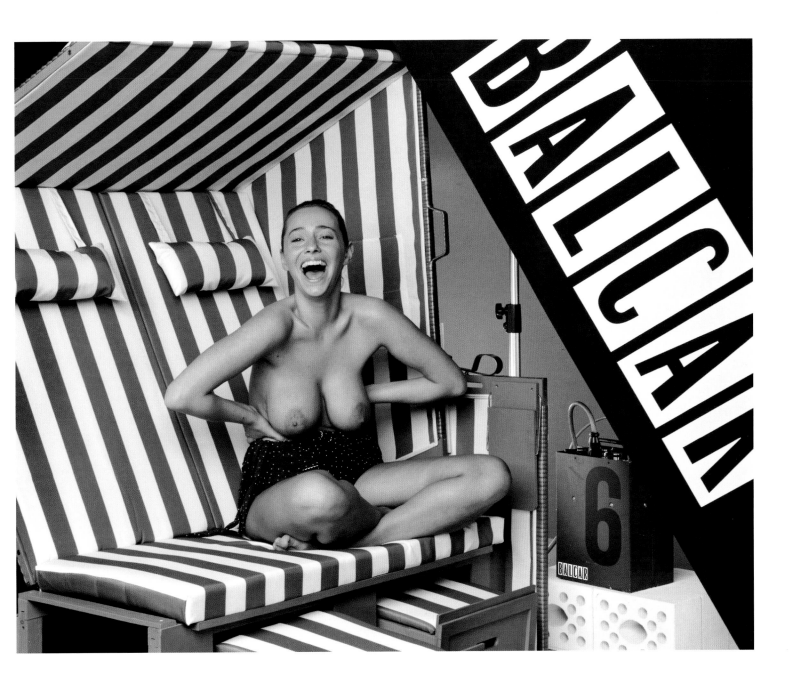

Christopher Williams
*TecTake Luxus Strandkorb grau/weiß*
*Model no.: 400636*
*Material: wood/plastic*
*Dimensions (height/width/depth): 154 cm × 116 cm × 77 cm*
*Weight: 49 kg*
*Manufactured by Ningbo Jin Mao Import & Export Co., Ltd,*
*Nigbo, Zhejiang, China for TecTake GmbH,*
*Igersheim, Germany*
*Model: Zimra Geurts, Playboy Netherlands Playmate of*
*the Year 2012*
*Studio Rhein Verlag, Düsseldorf*
*February 1, 2013*
*(Zimra stretching), 2013*

A marked difference between the practices of Renger-Patszch and Williams is that the former would normally choose one image to represent his subject. Williams is contemporary in that he recognizes that any single shot, compelling as it might be, is only one from a potential continuum of images. His two photographs of the Water and Power building, taken minutes apart, are subtly different, one image emphasizing the building's verticality, the other its horizontality. Indeed many of his works painstakingly present a series of views of the same subject, reflecting both a quasi-scientific approach to documentary and a resistance to declaring any one image definitive.

This is characteristic of many artists who, in an apparent paradox, are both intensely committed to composition yet acknowledge alternative possibilities. Wall has made two other Diagonal Compositions. An untitled work from 2007 by Kelm consists of four photographs of branches bearing calamondin fruit (a cross between an orange and a kumquat), all against a green background. Opie can show two portraits from the same shoot, rather than selecting one as definitive. Lassry's 2011 diptych of two cats (p. 128) prompts him to ask the elliptical question, "Is the cat more of a subject or an object?"[70] All of these strategies acknowledge the various challenges to photography's claims of unqualified truth by offering alternative, equally valid takes on the subject. Yet at the same time these works demonstrate in their subtle differences the control of the artists over each detail of the composition they have made.

Benjamin's hostility toward a photographic practice not rooted in explicit material facts was based less in the inherent objectivity of the medium or the lack of it than in his understanding that "this photography's most dream-laden subjects are a forerunner more of its salability than of any knowledge it might produce."[71] It is disqualified from seriousness by its association with commodification. This fear of taint by association with the world of advertising was to be one of the great underlying factors in the development of photography since the 1930s. Even after color photography became widely available, serious photographers treated it with suspicion. Because of its early adoption for commercial uses, for many years it seemed unsuited to ambitious work despite, for example, the extraordinary work of Paul Outerbridge, a photographer who worked in the commercial world at the same time as he made his own work. Color became associated with commerce, with luxury, and with frivolity; black and white

70   Elad Lassry, e-mail to the author, October 10, 2014.
71   Benjamin, "Little History of Photography," 526.

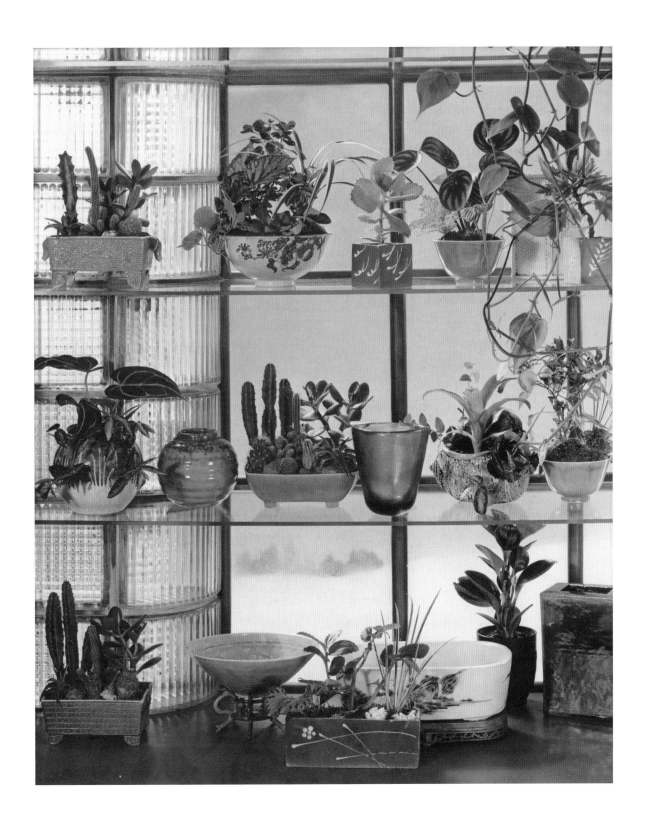

Paul Outerbridge
*Window with Plants*, 1937

William Eggleston
Untitled (from 14 Pictures), 1974

represented objectivity and seriousness. Even today, when color is the norm in almost all photography, black and white retains a strong presence in art photography, even at the risk of the now unavoidable connotation of nostalgia. As Andreas Huyssen has written,

> the opposition between modernism and mass culture has remained amazingly resilient over the decades. To argue that this simply has to do with the inherent "quality" of the one and the depravations of the other–correct as it may be in the case of many specific works–is to perpetuate the time-worn strategy of exclusion; it is itself a sign of the anxiety of contamination.[72]

This fear of contamination was a large part of why color photography–always associated with mass culture–remained severely marginalized in an art context until the 1970s. William Eggleston's solo exhibition at the Museum of Modern Art in 1976 is widely considered the breakthrough event in institutional recognition of color work.

72  Andreas Huyssen, *After the Great Divide: Modernism, Mass Culture, Postmodernism* (Bloomington: Indiana University Press, 1986), vii.

Along with Stephen Shore, William Christenberry, and others, Eggleston was part of a generation that no longer saw color as off limits. All of these figures, however, continued to work in the broad tradition of documentary and street photography.

With Wall's large light box *The Destroyed Room* (1978), however, a new approach was emerging. While the composition of Wall's staged picture drew on Eugène Delacroix's *Death of Sardanapalus* (1827), the vehicle he chose for the image engaged directly with mass culture, and advertising in particular, since Wall modeled his light box on the illuminated advertising posters he had seen at bus stops. While on one level he pushed photography up the supposed hierarchy of art with his reference to nineteenth-century painting, at the same time he embraced the most brazenly commercial of formats in which to do so.

Equally, Tillmans published his work in popular magazines and sometimes did editorial assignments for them at the same time he was showing his work in art galleries and museums, actively refusing the established distinction between the two spheres and accepting both forms of distribution as equally valid. Somewhat to his frustration, he says,

> *People who missed this intentionally non-hierarchical parallelism of gallery spaces and print media in my work from the very beginning often assume today that I started as a commercial photographer and then crossed over into art. The fact that this isn't the case would be an unimportant biographical detail if it didn't reaffirm this hierarchical element I thought I had already overcome back then.*[73]

For many of those who have come after Tillmans, however, the distinction between commercial and personal work has become increasingly blurred. As Wall said in an interview with Blalock:

> *The engagement with what have often been seen as trivial and compromised studio types–like the still life that started out as a commercial product photograph–seem to have to do with finding those little voids in the canon that can still disturb the consensus of what is worth bothering to photograph in the first place. This whole direction is really complex and sophisticated, and has been an undercurrent throughout the history of modernism.*[74]

73  Tillmans, in Obrist, *Wolfgang Tillmans*, 77.
74  Wall, interview with Lucas Blalock, *Aperture*, no. 210 (Spring 2013): 43.

Roe Ethridge's work overtly breaks with the supposed division between commercial and art photography, often deliberately conflating the two. His (uncommissioned) *Peas and Pickles* (2014) features a setup in his studio made with the set designer Andy Harman, prominently including a can of Goya brand green pigeon peas. *Myla with Column* (2008) vaguely suggests a 1950s environment, although there is no explicit indication of that, and the photograph, of a model in the studio leaning on a column, is equally of the present. It certainly evokes the now dated world of the glamour pinup, another genre that has run on a parallel track to art photography for decades. But its composition seems to have taken place in multiple registers simultaneously. The column the model leans on seems disproportionately small, making her own proportions seem awkward. The two fabric backdrops clash with each other, and the entire composition is tilted off the horizontal.

*Thanksgiving 1984* (2009) is if anything more unsettling, since it represents a specific date in the relatively recent past. It began as a commission from the publication *Visionaire*, which asked 365 artists each to produce one image for a day of the year, to be collected for a digital desk calendar (ultimately a slightly different version of the image by Ethridge was used). The photograph offers a hyperreal vision of a straight teenage boy's ideal holiday guest (Ethridge was fourteen in 1984). Both the model and the food in front of her are professionally styled to create a seamless image of WASP perfection. The model's blank but perfectly blue eyes are windows into a seductive yet disturbing world of suburban plenty and repression. As one of the novelist Anthony Powell's characters is described, he "remains essentially American in believing all questions have answers, that there is an ideal life against which everyday life can be measured–but measured only in everyday terms, so that the ideal life would be another sort of everyday life."[75] This is the proposition Ethridge puts on the table. His photograph is simultaneously totally realistic and entirely imagined, but its fantasy world remains a relentless version of the everyday.

Ethridge learned his technique as a JC Penney–style catalogue photographer before discovering the work of Wall and Williams. Told in school that he had to "find his voice," he asked himself, "What if I don't have a voice? What if I have many voices?"[76] His subsequent work articulates that potential multiplicity, sometimes manifesting itself in found situations, sometimes in portraits, and sometimes in setup or commissioned shots as elaborate as *Thanksgiving* or as simple as *Yellow Phone* (2013, p. 114), which shows nothing more than a slightly dated telephone handset on a marble tabletop.

75  Anthony Powell, *Temporary Kings* (Boston: Little, Brown, 1973), 175. The passage continues: "It is somewhere at that point that Russell's difficulties lie."

76  Roe Ethridge, conversation with the author, September 10, 2014.

Roe Ethridge
*Myla with Column*, 2008

Roe Ethridge
*Thanksgiving 1984*, 2009

90

Roe Ethridge
*Peas and Pickles*, 2014

Lassry's work sometimes appears to mimic the tropes of commercial photography. *Chocolate Bars, Eggs, Milk* (2013) at first resembles a product shot, until it becomes apparent that it contains no identifiable product. Lassry, instead, is at pains to emphasize his work's marginal status between the image represented and the exhibited work itself. This is evident in the painted frames that match the dominant color within the picture in the works shown here. Photographic works such as *Melocco* (2009) or *Man (With Circles)* (2010) offer intriguing images, but in the end the pictorial content is never fully explained. "I'm interested in the images that circulate within our culture," he says, "and advertising is a massive component of what's in circulation. Yet I spend as much time with books and images that have been pulled out of circulation. My investigation is into the condition of the picture."[77] His work offers seductive, mysterious images and great formal elegance, but they withhold interpretation as individual works in favor of a more broadly ambiguous examination of the borderline between image and object. As he has described this condition:

> *My work is full of obstacles in the sense that it does look highly familiar and accessible. It does look like it's already "solved at first sight." It does look like it's part of a larger industry. There are all these clues in the initial interaction with the work that offer a safe space, and of course, they collapse very quickly, depending on how much you engage with the work.*[78]

Where Lassry seems almost at the point of detaching entirely from photography as a medium, Peter Holzhauer retains an interest in the found situation and the accidental juxtaposition. The differences between their work suggests the range that can be found today among artists who nevertheless share an engagement with the idea of the composed image. Like many of the photographers discussed here, Holzhauer admires the conceptually oriented work of artists such as the Bechers or Dan Graham, even as he keeps roots in the documentary tradition. In looking at the Bechers' work, he likes not just their systematic conceptual rigor but also "when you see things they didn't plan on, like a blurry car, or a person—which rarely occurs—or the spring leaves, when you can get a sense of the season."[79] *Kodiak* (2001) is a straightforward depiction of a fishing boat that could come directly from the documentary tradition. Yet the

77  Lassry, "On Display," 93.
78  Lassry, interview with Ryan Trecartin, *Interview*, September 2012, 142.

79  Peter Holzhauer, "Peter Holzhauer on New Topographics" (2009), lacmavideo on YouTube, available at https://www.youtube.com/watch?v=Dsn2j8mzVYQ.

Elad Lassry
*Chocolate Bars, Eggs, Milk*, 2013

Elad Lassry
*Melocco*, 2009

Elad Lassry
*Man (With Circles)*, 2010

Peter Holzhauer
*Kodiak*, 2001

Peter Holzhauer
*Cerritos*, 2008

artist is also self-consciously exploring the relationship of this image to the picturesque and its persistence in tourist photography, another area largely taboo to art photography. His *Cerritos* (2008) and *Orange Street* (2011) are also documentary photographs, but their overt aestheticism takes them to the edge of a more pictorial way of making images. It is the arrangement of colors in these scenes rather than any anecdotal event that interests the artist.

To think of photography as primarily a way of making a picture, especially a picture with compositional roots associated with painting, means–perhaps paradoxically–that questions of technique and, more broadly, the medium-specific aspects of photography tend to be downplayed by artists working in this way. Even someone as unequivocally a photographer as Serrano can say that "I am an artist first and a photographer second," and add bluntly that he has "no interest in the medium except as a means to an end."[80] At the conceptual end of the spectrum, Williams, who normally does not operate the camera himself, explains how his approach to making photographs grew out of his early work with photographs taken by others:

> *I realized that instead of appropriating the photograph I could just pull the whole system back and appropriate the entire site of production–including the studio and studio technicians–rather than appropriate the image itself. I discovered through that strategy that it was no longer necessary for me to operate the camera. In fact by occupying the role of the director I gained much more control over the content of the image, and a more productive relationship to the three-dimensional space in front of the camera.*[81]

This directorial approach is one that many of the artists discussed here have brought to their work. By stepping back from the mechanics of picture taking, the artist can concentrate instead on picture making. While the results remain immaculate in their technical aspects, the focus of the artist is on his or her control over the image itself. Whether the point of comparison is a painter whose every brushstroke is carefully weighed or a film director in charge of a set and a team of assistants, the key issue is the artist's responsibility for each detail of the finished work, for the composition.

80   Serrano, interview with Fusco, 86.
81   Williams, in Tasman and Taft, "Christopher Williams: The 19th Draft."

Peter Holzhauer
*Orange Street*, 2011

<u>Lucas Blalock</u>

<u>Clegg & Guttmann</u>

Born 1978 in Asheville, North Carolina
Lives in New York

Michael Clegg
Born 1957 in Dublin
Lives in Berlin

Martin Guttmann
Born 1957 in Jerusalem
Lives in Vienna

SOLO EXHIBITIONS

2015
*Rubbers*, Ramiken Crucible, New York
*A Farmer's Knowledge*, Galerie Rodolphe Janssen,
    Brussels, Belgium

2014
*Late Works*, White Flag Projects, Saint Louis
*Statements*, Art Basel, Switzerland

2013
*Assisted Camera*, Peter Lund, Oslo
*Id, Ed, Ad, Od*, Ramiken Crucible, New York
*Inside the White Cube*, White Cube, London

2012
Frieze Art Fair, London

2011
*xyz*, Ramiken Crucible, New York

SOLO EXHIBITIONS

2012
*Portraits and Other Cognitive Exercises 2001–2012*,
    BAWAG Contemporary, Vienna. Exh. cat.

2006
*Mach vs. Boltzmann*, Secession, Vienna. Traveled to
    Kunstverein Braunschweig, Germany. Exh. cat
*Social Sculptures, Community Portraits and Spontaneous Operas
    1990–2006*, Cornerhouse, Manchester.

1999
*Portraits, Still Lifes and Landscapes 1985–1999*, Galleria Civica
    di Arte Contemporanea, Trento, Italy. Exh. cat.

1989
*Portraits de groupes de 1980 à 1989*, CAPC Musée d'Art
    Contemporain de Bordeaux, France. Exh. cat.

BIBLIOGRAPHY

Blalock, Lucas. "Country Picnic." *Art in America*,
    May 2015.
——. *Inside the White Cube*. New York: Peradam/Ramiken,
    2014.
——. *The Stand In (or a Glass of Milk)*, PF no. 6. Los Angeles:
    Public Fiction, 2015.
——. *Towards a Warm Math*. New York: Hassla Books, 2011.
    Text by John Houck.
——. *Windows, mirrors, tabletops*. London: Mörel, 2013.
    Interview by David Campany.
Ceschel, Bruno, ed. *SPBH Book Club Vol VII by Lucas Blalock*.
    London: Self Publish, Be Happy, 2014.
Cotton, Charlotte. *Photography Is Magic*. New York:
    Aperture, 2015.
"Jeff Wall: On Pictures, Conversation with Lucas Blalock."
    *Aperture*, no. 210 (Spring 2013): 41–45.

BIBLIOGRAPHY

Bovier, Lionel, Markus Bosshard, and Jürg Trösch, eds.
    *Clegg & Guttmann: Modalities of Portraiture*. Zürich:
    JRP | Ringier, 2013. Texts by Tobia Bezzola, Michael
    Clegg, and Martin Guttmann.
*Clegg & Guttmann: Collected Portraits*. Stuttgart, Germany:
    Württembergischer Kunstverein, 1988.
*Clegg & Guttmann: Monument for Historical Change and Other
    Social Sculptures, Community Portraits and Spontaneous
    Operas, 1990–2005*. Vienna: Schlebrügge, 2005.
Von Bismarck, Beatrice. *The Open Public Library:
    Clegg & Guttmann*. Ostfildern, Germany: Cantz, 1994.
    Texts by Achim Könneke, Michael Lingner,
    and von Bismarck.

## Lynn Davis

Born 1944 in Minneapolis
Lives in Hudson, New York

SOLO EXHIBITIONS

2012
*Modern Views of Ancient Treasures–Dans le Monde Arabe: In the Footsteps of Ibn Battuta*, Studio la Città, Verona, Italy

2010
*Persistence of Form: Photographs 1978–2010*, Knoedler & Company, New York

2008
*India, Persia, China*, Bernheimer Fine Old Masters, Munich

2007
*Illumination*, Rubin Museum of Art, New York. Exh. cat.
*PHotoEspaña 07: Lynn Davis*, Museo Thyssen-Bornemisza, Madrid

2001
*Ice*, Edwynn Houk Gallery, New York

1999
*Photographs of the Puryear Installation*, J. Paul Getty Museum, Los Angeles

1992
*Lynn Davis: Egypt*, Lannan Foundation, Los Angeles

1990
*Lynn Davis Photographien*, Frankfurter Kunstverein, Frankfurt, Germany. Exh. cat.

1980
*Lynn Davis*, Robert Samuel Gallery, New York

BIBLIOGRAPHY

*Ice: Lynn Davis*. Los Angeles: BükAmerica, 2005.
*Lynn Davis: American Monument*. New York: Monacelli Press, 2004. Text by Witold Rybczynski.
*Lynn Davis: Space Project*. New York: Monacelli Press, 2009. Text by Alan Weisman.
Mann, A. T. *Lynn Davis: Sacred Landscapes*. New York: Sterling, 2010.
Weiermair, Peter, ed. *Lynn Davis: Bodywork, 1978–1985*. Zürich: Edition Stemmle, 1996.
Whitney, David, ed. *Lynn Davis: Monument*. Santa Fe: Arena Editions, 1999. Texts by Patti Smith and Rudolph Wurlitzer.

## Thomas Demand

Born 1964 in Munich
Lives in Berlin and Los Angeles

SOLO EXHIBITIONS

2014
*Pacific Sun*, Los Angeles County Museum of Art

2013
*Model Studies*, Graham Foundation, Chicago

2012
Museum of Contemporary Art Tokyo. Traveled to National Gallery of Victoria, Melbourne, Australia. Exh. cat.

2009
Neue Nationalgalerie, Berlin. Traveled to Museum Boijmans Van Beuningen, Rotterdam, Netherlands. Exh. cat.

2008
*Thomas Demand: Camera*, Hamburger Kunsthalle, Hamburg, Germany. Exh. cat.

2007
*L'esprit d'escalier*, Irish Museum of Modern Art, Dublin. Exh. cat.

2006
Serpentine Gallery, London. Exh. cat.

2005
The Museum of Modern Art, New York. Exh. cat.
*Phototrophy*, Kunsthaus Bregenz, Austria. Exh. cat.

2000
Fondation Cartier, Paris. Exh. cat.

BIBLIOGRAPHY

Bee, Andreas, ed. *Thomas Demand: Klause*. Cologne: Walther König, 2006. Texts by Dietmar Dath, Christian Demand, and Joachim Valentin.
Demand, Thomas. *Nationalgalerie*. London: SteidlMACK, 2009. Essay by Mark Godfrey.
Marcoci, Roxana. *Thomas Demand*. New York: The Museum of Modern Art, 2005. Texts by Jeffrey Eugenides and Marcoci.
*Thomas Demand: B&K+*. Cologne: Walther König, 2004. Texts by Douglas Fogle, Helmut Friedel, and Bart Lootsma.
*Thomas Demand: Model Studies*. Madrid: Ivory Press, 2012.

## Stan Douglas

Born 1960 in Vancouver
Lives in Vancouver

SOLO EXHIBITIONS

2014
The Fruitmarket Gallery, Edinburgh. Exh. cat.

2013
*Stan Douglas: Abandonment and Splendour*, Canadian
    Cultural Centre, Paris
*Photographs 2008–2013*, Carré d'Art–Musée d'Art
    Contemporain, Nîmes, France. Traveled as *Stan
    Douglas: Mise en scène* to Haus der Kunst, Munich;
    Nikolaj Kunsthal, Copenhagen; and Irish Museum
    of Modern Art, Dublin. Exh. cat.

2011
*Entertainment: Selections from Midcentury Studio*, The Power
    Plant, Toronto. Exh. cat.

2007
*Past Imperfect, Works 1986–2007*, Staatsgalerie and
    Württembergischer Kunstverein, Stuttgart,
    Germany. Exh. cat.

2005
*Inconsolable Memories*, Joslyn Art Museum, Omaha.
    Traveled to Morris and Helen Belkin Art Gallery,
    University of British Columbia, Vancouver; Art
    Gallery of York University, Toronto; and The
    Studio Museum in Harlem, New York. Exh. cat.

2002
*Journey into Fear*, Contemporary Art Gallery, Vancouver.
    Exh. cat.
*Journey into Fear*, Serpentine Gallery, London. Exh. cat.

1999
Vancouver Art Gallery. Traveled to Edmonton Art Gallery,
    Canada; The Power Plant, Toronto; Museum
    De Pont, Tilburg, Netherlands; and The Museum
    of Contemporary Art, Los Angeles. Exh. cat.

BIBLIOGRAPHY

Christ, Hans D., and Iris Dressler, eds. *Stan Douglas:
    Past Imperfect, Works 1986–2007*. Ostfildern, Germany:
    Hatje Cantz, 2008. Texts by Mieke Bal, Christa
    Blümlinger, Reinhard Braun, Christ, Iván De
    la Nuez, Dressler, Gudrun Inboden, George E. Lewis,
    Ivone Marguilies, and Charlotte Townsend-Gault.
Monk, Philip. *Stan Douglas*. Cologne: DuMont Literatur
    und Kunst Verlag, 2006.
Simoens, Tommy, ed. *Stan Douglas: Midcentury Studio*.
    Antwerp, Belgium: Ludion, 2011. Texts by Douglas,
    Christopher Phillips, and Pablo Sigg.

## Roe Ethridge

Born 1969 in Miami
Lives in New York

SOLO EXHIBITIONS

2015
*Double Bill (with Andy Harman and Special Guest Louise
    Parker)*, Greengrassi, London

2014
*Sacrifice Your Body*, Capitain Petzel, Berlin. Exh. cat.

2013
Gagosian Gallery, Beverly Hills, California
*A Moveable Feast–Part 1*, Campoli Presti, Paris

2012
Le Consortium, Dijon, France. Traveled to Museum
    Leuven, Belgium. Exh. cat.

2011
*Le Luxe*, Andrew Kreps Gallery, New York. Exh. cat.

2009
*Goodnight Flowers*, Rat Hole Gallery, Tokyo

2008
*Rockaway Redux*, Andrew Kreps Gallery, New York.
    Exh. cat.

2006
*Roe Ethridge: Apple and Cigarettes*, Gagosian Gallery,
    Beverly Hills, California. Exh. cat.

2005
*Momentum 4: Roe Ethridge*, Institute of Contemporary Art,
    Boston. Exh. cat.

2003
*Roe Ethridge: Junction*, Clough-Hanson Gallery at Rhodes
    College, Memphis

BIBLIOGRAPHY

Bywater, Roger, and Reid Shier, eds. *Roe Ethridge and
    Cheyney Thompson: Lynn Valley 6*. Vancouver:
    Presentation House Gallery; and Toronto: Bywater
    Bros. Editions, 2009.
Ethridge, Roe. *Farewell Horse*. Tokyo: Rat Hole Gallery,
    2009.
——. *Orange Grove*. New York: Andrew Kreps, 2004.
——. *Rockaway*. London: Mack Books, 2008.
——. *Spare Bedroom*. New York: Andrew Kreps, 2004.
——, and Bennett Simpson. *County Line*. Boston: Institute
    of Contemporary Art, 2005.

Born 1949 in Vancouver
Lives in Vancouver

## SOLO EXHIBITIONS

### 2014

*Props and Other Paintings*, Charles H. Scott Gallery, Emily
Carr University of Art & Design, Vancouver.
In conjunction with *Rodney Graham: Collected Works*,
Rennie Collection, Vancouver; and *Rodney
Graham: Torqued Chandelier Release and Other Works*,
Morris and Helen Belkin Gallery, University
of British Columbia, Vancouver

### 2010

*Rodney Graham: Through the Forest*, Museu d'Art
Contemporani de Barcelona, Spain. In conjunction
with *Possible Abstractions*, Museu Picasso,
Barcelona. Traveled to Kunstmuseum Basel/Museum
für Gegenwartskunst, Basel, Switzerland;
and Hamburger Kunsthalle, Hamburg, Germany.
Exh. cat.

### 2008

*A Glass of Beer*, Centro de Arte Contemporáneo de Málaga,
Spain. Exh. cat.

### 2006

*A group of literary, musical, sculptural, photographic and
film pieces*, Musée d'Art Contemporain de Montréal,
Canada. Exh. cat.

### 2004

*A Little Thought*, Art Gallery of Ontario, Toronto.
Traveled to The Museum of Contemporary Art,
Los Angeles; Vancouver Art Gallery; and Institute
of Contemporary Art, Philadelphia. Exh. cat.

### 2002

Whitechapel Art Gallery, London. Traveled to K21
Kunstsammlung Nordrhein-Westfalen, Düsseldorf,
Germany; and Ville de Marseille/MAC, galeries
contemporaines des Musées de Marseille, France.
Exh. cat.

### 1997

*Vexation Island*, Canadian Pavilion, La Biennale di
Venezia, Venice, Italy

## BIBLIOGRAPHY

Arnold, Grant, Jessica Bradley, and Cornelia H. Butler,
eds. *Rodney Graham: A Little Thought*. Toronto:
Art Gallery of Ontario; and Los Angeles:
The Museum of Contemporary Art, 2004. Texts
by Arnold, Butler, Lynne Cooke, Diedrich
Diederichsen, Sara Krajewski, and Shepherd Steiner.

Graham, Rodney, ed. *British Weathervanes*. New
York: Christine Burgin/Donald Young, 2011.
Texts by Iwona Blazwick, John Slyce, Candy Stobbs,
and Desiderius Erasmus.

Graham, Rodney. *Wet on Wet: My Late Early Styles*.
Cologne: Walther König, 2008.

Keller, Christoph, and Kathy Slade, eds. *The Rodney Graham
Song Book*. Zürich: JRP | Ringier, 2007.

Steiner, Shepherd. *Rodney Graham: Phonokinetoscope*.
London: Afterall; and Cambridge, MA:
MIT Press, 2013.

## Andreas Gursky

Born 1955 in Leipzig, Germany
Lives in Düsseldorf

SOLO EXHIBITIONS

2014
National Art Center, Tokyo. Traveled to the National
    Museum of Art, Osaka, Japan. Exh. cat.

2012
*Andreas Gursky at Louisiana*, Louisiana Museum of Modern
    Art, Humlebaek, Denmark. Exh. cat.
*Andreas Gursky: Bangkok*, Stiftung Museum Kunstpalast,
    Düsseldorf, Germany. Exh. cat.

2008
*Andreas Gursky: Works 80–08*, Kunstmuseen Krefeld,
    Germany. Traveled to Moderna Museet, Stockholm;
    and Vancouver Art Gallery. Exh. cat.

2007
*Retrospektive 1984–2007*, Haus der Kunst, Germany.
    Traveled to Istanbul Museum of Modern Art;
    Sharjah Art Museum, United Arab Emirates;
    Ekaterina Foundation, Moscow; and National
    Gallery of Victoria, Melbourne, Australia. Exh. cat.

2001
The Museum of Modern Art, New York. Traveled to
    Museo Nacional Centro de Arte Reina Sofía,
    Madrid; Centre Georges Pompidou, Paris; Museum
    of Contemporary Art Chicago; and San Francisco
    Museum of Modern Art. Exh. cat.

1995
*Andreas Gursky: Images*, Tate Gallery Liverpool, England.
    Exh. cat.

1994
*Andreas Gursky: Fotografien 1984–1993*, Deichtorhallen,
    Hamburg, Germany. Traveled to De
    Appel Foundation, Amsterdam. Exh. cat.

BIBLIOGRAPHY

*Andreas Gursky*. Beverly Hills, California: Gagosian
    Gallery, 2010. Texts by Norman Bryson and
    Werner Spies.
Galassi, Peter. *Andreas Gursky*. New York: The Museum
    of Modern Art, 2001.
Hentschel, Martin. *Andreas Gursky: Works 80–08*.
    Ostfildern, Germany: Hatje Cantz, 2008.

## Peter Holzhauer

Born 1978 in Portland, Oregon
Lives in Los Angeles

GROUP EXHIBITIONS

2013
*Ensuing Pictures: The Peer-to-Peer Exhibition*, Concourse
    Gallery, Emily Carr University of Art & Design,
    Vancouver. Exh. cat.

2012
*Moments Measured*, Los Angeles County Museum of Art
*Poule!*, Fundación/Colección Jumex, Ecatepec, Mexico.
    Exh. cat.

2010
*Assembly: Eight Emerging Photographers from Southern
    California*, FotoFest 2010, Houston. Exh. cat.

2007
Biennial, Portland Museum of Art, Maine. Exh. cat.

2005
*Vital Signs*, George Eastman House, Rochester,
    New York. Exh. cat.

BIBLIOGRAPHY

Harren, Natilee, and Chris Lipomi. *BOUNTY*, 3.
    Los Angeles: Gyre & Gymble Publications, 2012.
Holzhauer, Peter. *Blind Spot*, no. 47 (2014): 88.
——. *N+1*, no. 20 (2014): 12.
——. *The Marine Layer*. San Francisco: Blurb, 2008.
——. "Wallpaper." *Blind Spot*, no. 33 (2006): 37–44.

Annette Kelm

Born 1975 in Stuttgart, Germany
Lives in Berlin

SOLO EXHIBITIONS

2014
*Annette Kelm: Staub*, Kölnischer Kunstverein, Cologne.
    Exh. cat.

2012
Presentation House Gallery, Vancouver. Exh. cat.

2008
Witte de With, Rotterdam, Netherlands. Traveled to
    Kunsthalle Zürich, Switzerland; and KW–Institute
    for Contemporary Art, Berlin. Exh. cat.

2006
*Annette Kelm: Errors in English*, Art Cologne Prize
    for Young Artists, Artothek, Cologne. Exh. cat.

2004
*Annette Kelm: To a Snail*, Galerie Crone, Berlin. Exh. cat.

GROUP EXHIBITIONS

2013
*New Photography 2013*, The Museum of Modern Art,
    New York

2011
*ILLUMInations*, 54th International Art Exhibition, La
    Biennale di Venezia, Venice, Italy. Exh. cat.
*The Anxiety of Photography*, Aspen Art Museum, Colorado.
    Exh. cat.

2007
*Passengers*, CCA Wattis Institute for Contemporary Arts,
    San Francisco. Exh. cat.
*The History of a Decade that Has Not Yet Been Named*,
    9th Biennale d'Art Contemporain, Lyon, France.
    Exh. cat.

BIBLIOGRAPHY

Asthoff, Jens. "Annette Kelm." *Camera Austria*, no. 102
    (July 2008): 11–24.
Hoffmann, Jens. "Openings: Annette Kelm." *Artforum*
    (January 2008): 267–69.

Elad Lassry

Born 1977 in Tel Aviv, Israel
Lives in Los Angeles

SOLO EXHIBITIONS

2015
David Kordansky Gallery, Los Angeles

2014
*Sensory Spaces 3: Elad Lassry*, Museum Boijmans Van
    Beuningen, Rotterdam, Netherlands

2012
*Elad Lassry: Untitled (Presence)*, The Kitchen, New York

2011
White Cube, Hoxton Square, London. Exh. cat.

2010
*Elad Lassry: Sum of Limited Views*, Contemporary Art
    Museum, Saint Louis
Kunsthalle Zürich. Exh. cat.
Luhring Augustine, New York. Exh. cat.

2009
*Elad Lassry: Three Films*, Whitney Museum of American
    Art, New York

2008
The Art Institute of Chicago

BIBLIOGRAPHY

*Elad Lassry: On Onions*. New York: Primary Information,
    2012. Text by Angie Keefer.
Gioni, Massimiliano, and Karen Marta, eds. *Elad
    Lassry: 2000 Words*. Athens: DESTE Foundation for
    Contemporary Art, 2013. Text by Tim Griffin.
Rabottini, Alessandro, ed. *Elad Lassry*. Milan: Mousse
    Publishing, 2014. Texts by Jörg Heiser, Elad Lassry,
    Aram Moshayedi, and Rabottini.
Ruf, Beatrix, ed. *Elad Lassry*. Zürich: JRP | Ringier, 2011.
    Texts by Bettina Funcke, Liz Kotz, Fionn Meade,
    and Ruf.

## Sharon Lockhart

Born 1964 in Norwood, Massachusetts
Lives in Los Angeles

SOLO EXHIBITIONS

2013
*Milena, Milena*, Centre for Contemporary Art,
  Ujazdowski Castle, Warsaw, Poland. Traveled
  to Bonniers Konsthall, Stockholm; and
  Kunstmuseum Luzern, Switzerland. Exh. cat.

2011
*Sharon Lockhart | Noa Eshkol*, Israel Museum, Jerusalem.
  Co-organized by Los Angeles County Museum
  of Art. Traveled to The Jewish Museum, New York.
  Exh. cat.

2010
*Sharon Lockhart: Lunch Break*, Mildred Lane Kemper Art
  Museum, Saint Louis. Traveled to Colby
  College Museum of Art, Waterville, Maine;
  and San Francisco Museum of Modern Art. Exh. cat.

2008
*Lunch Break*, Secession, Vienna. Exh. cat.

2001
Museum of Contemporary Art Chicago. Traveled to
  Museum of Contemporary Art San Diego. Exh. cat.

2000
*Teatro Amazonas*, Museum Boijmans Van Beuningen,
  Rotterdam, Netherlands. Traveled to Kunsthalle
  Zürich: Kunstmuseum Wolfsburg, Germany;
  and Wako Works of Art, Tokyo. Exh. cat.

1998
*Goshogoaka Girls Basketball Team*, Friedrich Petzel Gallery,
  New York. Traveled to Blum & Poe, Santa Monica,
  California; and Wako Works of Art, Tokyo. Exh. cat.

BIBLIOGRAPHY

*Sharon Lockhart: Pine Flat*. Minneapolis: Walker Art
  Center; and Milan: Charta, 2006. Texts by
  Kathy Halbreich, Linda Norden, and Frances Stark.

## Florian Maier-Aichen

Born 1973 in Stuttgart, Germany
Lives in Cologne and Los Angeles

SOLO EXHIBITIONS

2014
Blum & Poe, Los Angeles
303 Gallery, New York

2013
Gagosian Gallery, London
Gagosian Gallery, Hong Kong

2011
Galerie Baronian Francey, Brussels

2009
*Snow Machine*, Gagosian Gallery, London. Exh. cat.

2008
*PHotoEspana 08: Florian Maier-Aichen*, Museo
  Thyssen-Bornemisza, Madrid. Exh. cat.

2007
*MOCA Focus: Florian Maier-Aichen*, The Museum of
  Contemporary Art, Los Angeles. Exh. cat.

GROUP EXHIBITIONS

2006
Whitney Biennial, Whitney Museum of American
  Art, New York. Exh. cat.

2001
*Snapshot: New Art from Los Angeles*, UCLA Hammer
  Museum, Los Angeles. Traveled to the
  Museum of Contemporary Art, North Miami.
  Exh. cat.

BIBLIOGRAPHY

*Florian Maier-Aichen*. Madrid: La Fábrica, 2008. Texts
  by Sérgio Mah and Christy Lange.

## Robert Mapplethorpe

Born 1946 in New York
Died 1989 in Boston

SOLO EXHIBITIONS

2016
J. Paul Getty Museum, Los Angeles, and Los Angeles
    County Museum of Art

2009
*Robert Mapplethorpe: Perfection in Form*, Galleria
    dell'Accademia, Florence. Traveled to Museo d'Arte
    della Città di Lugano, Switzerland. Exh. cat.

2008
*Polaroids: Mapplethorpe*, Whitney Museum of American
    Art, New York. Exh. cat.

2004
*Robert Mapplethorpe and the Classical Tradition: Photographs
    and Mannerist Prints*, Deutsche Guggenheim, Berlin.
    Traveled to State Hermitage Museum, Saint
    Petersburg, Russia; and Solomon R. Guggenheim
    Museum, New York. Exh. cat.

1992
*Mapplethorpe*, Louisiana Museum of Modern Art,
    Humlebaek, Denmark. Traveled to Castello di
    Rivoli Museo d'Arte Contemporanea, Turin, Italy.
    Exh. cat.

1988
*Mapplethorpe Portraits: Photographs by Robert Mapplethorpe
    1975–87*, National Portrait Gallery, London. Exh. cat.
*Robert Mapplethorpe: The Perfect Moment*, Institute
    of Contemporary Art, University of Pennsylvania,
    Philadelphia. Traveled to seven American
    venues. Exh. cat.
Whitney Museum of American Art, New York. Exh. cat.

1983
*Robert Mapplethorpe: 1970–1983*, Institute of Contemporary
    Arts, London. Exh. cat.

1978
*Robert Mapplethorpe: Photographs*, Chrysler Museum of Art,
    Norfolk, Virginia. Exh. cat.

1973
*Polaroids*, Light Gallery, New York

BIBLIOGRAPHY

Danto, Arthur C. *Robert Mapplethorpe*. New York: Random
    House, 1992.
*Mapplethorpe The Complete Flowers*. Kempen, Germany:
    teNeues, 2006. Text by Herbert Muschamp.
Smith, Patti. *Just Kids*. New York: Ecco, 2010.

## McDermott & McGough

David McDermott
Born 1952 in Hollywood, California
Lives in New York and Dublin

Peter McGough
Born 1958 in Syracuse, New York
Lives in New York and Dublin

SOLO EXHIBITIONS

2015
*Cyan Light Abstract*, M77 Gallery, Milan

2014
*McDermott & McGough: Culmination*, Vito Schnabel,
    New York

2013
*Suspicious of Rooms without Music or Atmosphere*, Cheim &
    Read, New York. Exh. cat.

2010
*26 Sandymount Avenue*, Kunsthalle Wien, Vienna. Exh. cat.

2008
*An Experience of Amusing Chemistry: Photographs 1990–1890*,
    Irish Museum of Modern Art, Dublin.
    Traveled to Maison Européenne de la Photographie,
    Paris; and Manezh Central Exhibition Hall,
    Moscow. Exh. cat.
*Because of Him*, Cheim & Read, New York. Exh. cat.
*Detroit: Carbro Prints 1958*, Nicholas Robinson Gallery,
    New York. Traveled to Andy Warhol Museum,
    Pittsburgh. Exh. cat.

2003
*Hitler and the Homosexuals: The Lust that Comes from Nothing*,
    Akureyri Art Museum, Iceland

1997
*Messrs McDermott & McGough: Paintings, Photographs
    and Time Experiments 1950*, Provincial
    Museum of Modern Art, Ostend, Belgium

BIBLIOGRAPHY

*McDermott & McGough: 1936*. Milan: Charta, 1996.
*McDermott & McGough: A History of Photography*. Santa Fe:
    Arena Editions, 1998. Text by Mark Alice Durant.
Tsuzuki, Kyoichi, ed. *Messers McDermott & McGough*. Art
    Random Series, no. 57 (Kyoto, Japan: Shoin, 1991).

## Catherine Opie

Born 1961 in Sandusky, Ohio
Lives in Los Angeles

SOLO EXHIBITIONS

2011
*Catherine Opie: Empty and Full*, Institute of Contemporary Art, Boston. Exh. cat.

2010
*Catherine Opie: Figure and Landscape*, Los Angeles County Museum of Art

2008
*Catherine Opie: American Photographer*, Solomon R. Guggenheim Museum, New York. Exh. cat.

2006
*Catherine Opie: Chicago*, Museum of Contemporary Art Chicago. Exh. cat.
*Catherine Opie: 1999 and In and Around Home*, Aldrich Contemporary Art Museum, Ridgefield, Connecticut. Traveled to Orange County Museum of Art, Newport Beach, California; Cleveland Museum of Contemporary Art; and Weatherspoon Art Museum, Greensboro, North Carolina. Exh. cat.

2002
*Catherine Opie: Skyways and Icehouses*, Walker Art Center, Minneapolis. Exh. cat.

2000
*Catherine Opie: In between here and there*, Saint Louis Art Museum. Exh. cat.
*Altered States of America: Catherine Opie*, The Photographers' Gallery, London. Traveled to Museum of Contemporary Art Chicago. Exh. cat.

1997
The Museum of Contemporary Art, Los Angeles. Exh. cat.

BIBLIOGRAPHY

Blessing, Jennifer. *Catherine Opie: American Photographer*. New York: Guggenheim Museum, 2008. Texts by Dorothy Allison, Blessing, Russell Ferguson, and Nat Trotman.
*Catherine Opie: Inauguration*. New York: Gregory R. Miller, 2011. Texts by Deborah Willis and Eileen Myles.
Phillips, Brian, ed. *Rodarte, Catherine Opie, Alec Soth*. Zürich: JRP | Ringier, 2011. Text by John Kelsey.

## Barbara Probst

Born 1964 in Munich
Lives in New York and Munich

SOLO EXHIBITIONS

2014
*Barbara Probst: Total Uncertainty*, Galerie Rudolfinum, Prague. Exh. cat.

2013
National Museum of Photography, Copenhagen. Traveled to CentrePasquArt, Biel, Switzerland. Exh. cat.

2009
Kunstverein Oldenburg, Germany

2007
*Barbara Probst: Exposures*, Museum of Contemporary Photography, Chicago. Traveled to Madison Museum of Contemporary Art, Wisconsin. Exh. cat.

2002
Kunstverein Cuxhaven, Germany. Exh. cat.

BIBLIOGRAPHY

Probst, Barbara. *Barbara Probst*. Munich: Barbara Probst, 1998.
——. *InExpectation*. Munich: Barbara Probst, 1998.
——. *My Museum*. Munich: Kulturreferat München, 1994.
——. *Through the Looking Glass*. Munich: Barbara Probst, 1998.
——. *Welcome*. Munich: Barbara Probst, 1998. Text by Thomas Dreher.

## Thomas Ruff

Born 1958 in Zell am Harmersbach, Germany
Lives in Düsseldorf

SOLO EXHIBITIONS

2014
*Lichten*, Stedelijk Museum voor Actuele Kunst, Ghent,
    Belgium. Traveled to Kunsthalle Düsseldorf.
    Exh. cat.

2012
Haus der Kunst, Munich. Exh. cat.

2009
Castello di Rivoli, Museo d'Arte Contemporanea, Turin,
    Italy. Exh. cat.

2001
*Thomas Ruff: Photography 1979 to the Present*, Staatliche
    Kunsthalle Baden-Baden, Germany.
    Traveled to Museet for Samtidskunst, Oslo;
    Museum Folkwang, Essen, Germany;
    Städtische Galerie im Lenbachhaus, Munich; Irish
    Museum of Modern Art, Dublin; Artium
    Centro-Museo Vasco de Arte Contemporáneo,
    Vitoria Gasteiz, Spain; Museu Serralves, Porto,
    Portugal; Tate Liverpool; and Centre for
    Contemporary Art, Ujazdowski Castle, Warsaw,
    Poland. Exh. cat.

1991
Kunstverein Bonn, Germany. Traveled in Germany
    to Kunstverein Arnsberg; Kunstverein
    Braunschweig; and Galerie der Stadt Sindelfingen.
    Exh. cat.

1989
*Thomas Ruff: Porträts, Häuser, Sterne*, Stedelijk Museum,
    Amsterdam. Traveled to Le Magasin–Centre
    National d'Art Contemporain, Grenoble, France;
    and Kunsthalle Zürich. Exh. cat.

1988
*Thomas Ruff: Porträts*, Museum Schloss Hardenberg,
    Velbert, Germany. Traveled to Portikus, Frankfurt,
    Germany. Exh. cat.

BIBLIOGRAPHY

Kramer, Markus. *Thomas Ruff: Modernism*. Heidelberg,
    Germany: Kehrer Verlag, 2012.
Simpson, Bennett. *Thomas Ruff: jpegs*. New York:
    Aperture and David Zwirner, 2009.
*Thomas Ruff: Series*. Madrid: La Fábrica, 2013. Interview by
    José Manuel Costa.
*Thomas Ruff: Works 1979–2011*. Munich: Schirmer/Mosel,
    2012. Texts by Okwui Enwezor, Valeria Liebermann,
    and Thomas Weski.

## Andres Serrano

Born 1950 in New York
Lives in New York

SOLO EXHIBITIONS

2014
Palais Fesch Musée des Beaux-Arts, Ajaccio, France.
    Exh. cat.
*Residents of New York*, More Art, New York

2013
*Cuba*, Yvon Lambert, Paris

2011
*Andres Serrano: Holy Works*, Galleria Pack, Milan.
    Exh. cat.

2000
*Body and Soul*, Bergen Art Society, Norway. Traveled
    to Rogaland Kunst Museum, Stavanger,
    Norway; Tromsø Art Society, Norway;
    Stenersenmusett, Oslo; Helsinki City Art Museum;
    Čiurlionis National Museum of Art, Kaunas,
    Lithuania; Ludwig Foundation, Aachen, Germany;
    and Barbican Art Centre, London. Exh. cat.

1997
*A History of Andres Serrano: A History of Sex*, Groninger
    Museum, Groningen, Netherlands. Exh. cat.

1994
*Andres Serrano: Works 1983–93*, Institute of Contemporary
    Art, University of Pennsylvania, Philadelphia.
    Traveled to New Museum of Contemporary Art,
    New York; Center for the Fine Arts, Miami;
    Contemporary Arts Museum Houston; Museum
    of Contemporary Art Chicago; and Malmö
    Konsthall, Sweden. Exh. cat.

BIBLIOGRAPHY

*Andres Serrano: America and Other Work*. Cologne: Taschen,
    2004.
*Andres Serrano: Placing Time and Evil*. Bergen,
    Norway: Stiftelsen, 2000. Texts by Malin Barth
    and Trond Borgen.
Wallis, Brian, ed. *Andres Serrano: Body and Soul*. New
    York: Takarajima Books, 1995. Texts by Amelia
    Arenas, Bruce Ferguson, and bell hooks.

## Hiroshi Sugimoto

Born 1948 in Tokyo
Lives in New York and Tokyo

2014
*Hiroshi Sugimoto: The Glass Tea House Mondrian*,
    Fondazione Giorgio Cini, organized by Le Stanze
    del Vetro, Isola di San Giorgio Maggiore,
    Venice, Italy
*Hiroshi Sugimoto: Past Tense*, J. Paul Getty Museum,
    Los Angeles

2013
Leeum, Samsung Museum of Art, Seoul. Exh. cat.

2012
*Hiroshi Sugimoto: Revolution*, Museum Brandhorst, Munich.
    Traveled to Les Rencontres d'Arles Photographie,
    Espace Van Gogh, Arles, France. Exh. cat.

2005
*Hiroshi Sugimoto: End of Time*, Mori Art Museum, Tokyo.
    Traveled to Hirshhorn Museum and Sculpture
    Garden, Washington, DC as *Hiroshi Sugimoto*;
    Modern Art Museum of Fort Worth, Texas; de Young
    Museum, San Francisco; K20 Kunstsammlung
    Nordrhein-Westfalen, Düsseldorf, Germany;
    Museum der Moderne, Salzburg, Austria; Neue
    Nationalgalerie, Staatliche Museen zu Berlin; and
    Kunstmuseum Luzern, Switzerland. Exh. cat.
*Hiroshi Sugimoto: History of History*, Japan Society, New
    York. Traveled to Arthur M. Sackler Gallery,
    Washington, DC; Royal Ontario Museum, Toronto;
    Asian Art Museum, San Francisco; 21st Century
    Museum of Contemporary Art, Kanazawa,
    Japan; and National Museum of Art, Osaka, Japan.
    Exh. cat.

1994
The Museum of Contemporary Art, Los Angeles.
    Traveled to Parrish Art Museum, Southampton,
    New York, as *Hiroshi Sugimoto: Time Exposed*; and
    Museum of Contemporary Art Chicago as *Options
    49: Hiroshi Sugimoto*. Exh. cat.

BIBLIOGRAPHY

*Hiroshi Sugimoto*. Ostfildern, Germany: Hatje Cantz, 2010.
    Texts by Kerry Brougher, Pia Müller-Tamm,
    and Hiroshi Sugimoto.
*Hiroshi Sugimoto: Conceptual Forms and Mathematical Models*.
    Stuttgart, Germany: Hatje Cantz, 2015. Texts by
    Sugimoto and Klaus Ottmann.
*Hiroshi Sugimoto: Dioramas*. New York: Pace Gallery; and
    Bologna, Italy: Damiani, 2014.

## Wolfgang Tillmans

Born 1968 in Remscheid, Germany
Lives in London and Berlin

SOLO EXHIBITIONS

2012
Moderna Museet, Stockholm. Traveled to
Kunstsammlung Nordrhein-Westfalen, Düsseldorf,
Germany. Exh. cat.

2010
Serpentine Gallery, London. Exh. cat.

2008
*Wolfgang Tillmans: Lighter*, Hamburger Bahnhof, Museum
für Gegenwart, Berlin. Exh. cat.

2006
Museum of Contemporary Art Chicago. Traveled
to Hammer Museum, Los Angeles;
Hirshhorn Museum and Sculpture Garden,
Washington, DC; and Rufino Tamayo Museum,
Mexico City. Exh. cat.

2003
*Wolfgang Tillmans: If One Thing Matters, Everything
Matters*, Tate Britain, London. Exh. cat.

2002
*Wolfgang Tillmans: Still Life*, Fogg Art Museum, Harvard
University, Cambridge, Massachusetts. Exh. cat.

2001
*Wolfgang Tillmans: View from Above*, Deichtorhallen,
Hamburg, Germany. Traveled to Castello di Rivoli,
Museo d'arte contemporanea, Turin, Italy;
Palais de Tokyo, Paris; and Louisiana Museum
of Modern Art, Humlebaek, Denmark. Exh. cat.

1995
Kunsthalle Zürich. Exh. cat.

BIBLIOGRAPHY

Obrist, Hans Ulrich, ed. *Wolfgang Tillmans*. The
Conversation Series, no. 6. Cologne: Walther
König, 2007.
Riemschneider, Burkhard, ed. *Wolfgang Tillmans*.
Cologne: Taschen, 1995.
*Wolfgang Tillmans*. Chicago: Museum of Contemporary
Art; and Los Angeles: Hammer Museum, 2006.
Texts by Julie Ault, Daniel Birnbaum,
Russell Ferguson, Dominic Molon, Lane Relyea,
and Mark Wigley.
*Wolfgang Tillmans*. London: Phaidon Press, 2014.
Interview by Peter Halley and texts by Johanna
Burton, Midori Matsui, Caroline Stephen,
Tillmans, and Jan Verwoert.

## Jeff Wall

Born 1946 in Vancouver
Lives in Vancouver and Los Angeles

SOLO EXHIBITIONS

2014
*Jeff Wall: Tableaux Pictures Photographs 1996–2013*, Stedelijk
Museum, Amsterdam. Traveled to Kunsthaus
Bregenz, Austria; and Louisiana Museum
of Modern Art, Humlebaek, Denmark. Exh. cat.

2007
The Museum of Modern Art, New York. Traveled
to The Art Institute of Chicago; and San Francisco
Museum of Modern Art. Exh. cat.

2005
*Jeff Wall Photographs: 1978–2004*, Schaulager, Basel,
Switzerland. Traveled to Tate Modern, London.
Exh. cat.

1997
Hirshhorn Museum and Sculpture Garden, Washington,
DC. Traveled to The Museum of Contemporary
Art, Los Angeles; and Art Tower Mito, Japan. Exh. cat.

1995
Museum of Contemporary Art Chicago. Traveled
to Galerie Nationale du Jeu de Paume, Paris;
Kiasma–Museum of Contemporary Art, Helsinki;
and Whitechapel Art Gallery, London. Exh. cat.

1984
*Jeff Wall: Transparencies*, Institute of Contemporary
Arts, London. Traveled to Kunsthalle Basel,
Switzerland. Exh. cat.

BIBLIOGRAPHY

Galassi, Peter. *Jeff Wall*. New York: The Museum
of Modern Art, 2007. Interview by James Rondeau.
*Jeff Wall: Photographs*. Cologne: Walther König, 2003.
Texts by Peter Bürger, Homay King, Tom Holert,
Achim Hochdörfer, Lisa Joyce and Fred Orton,
Kaja Silverman, Gregor Stemmrich, and Friedrich
Tietjen.
Wall, Jeff. *Jeff Wall: Selected Essays and Interviews*.
New York: The Museum of Modern Art, 2007. Texts
by Wall; interviews by Els Barents; Anne-Marie
Bonnet and Rainer Metzer; Jean-François Chevrier;
T. J. Clark, Claude Gintz, Serge Gilbaut, and
Anne Wagner; Boris Groys; Mark Lewis; Arielle
Pelenc; John Roberts; Martin Schwander;
David Shapiro; and Dirk Snauwaert.
——. *Jeff Wall: Works and Collected Writings*. Barcelona:
Poligrafa, 2007. Texts by Michael Newman
and Wall.

## Gillian Wearing

Born 1963 in Birmingham, England
Lives in London

### SOLO EXHIBITIONS

2014
*Rose Video 05: Gillian Wearing*, The Rose Art Museum,
    Brandeis University, Waltham, Massachusetts
*We Are Here*, The New Art Gallery Walsall, England

2012
Whitechapel Art Gallery, London. Traveled to K20
    Kunstsammlung Nordrhein-Westfalen, Düsseldorf,
    Germany; and Pinakothek der Moderne,
    Munich. Exh. cat.

2002
*Gillian Wearing: Mass Observation*, Museum of
    Contemporary Art Chicago. Traveled to Musée
    d'Art Contemporain de Montréal; and Institute
    of Contemporary Art, University of Pennsylvania,
    Philadelphia. Exh. cat.
*Gillian Wearing: A Trilogy*, Vancouver Art Gallery. Traveled
    to Kunsthaus Glarus, Switzerland. Exh. cat.

2000
Serpentine Gallery, London
La Caixa, Madrid. Traveled to Centro Galego de Arte
    Contemporánea, Santiago de Compostela, Spain.
    Exh. cat.

### BIBLIOGRAPHY

*Gillian Wearing*. London: Phaidon, 1999. Texts by Donna
    De Salvo, Russell Ferguson, and John Slyce.
*Gillian Wearing*. London: Whitechapel Gallery, 2012.
    Texts by David Deamer, Daniel F. Herrmann, Doris
    Krystof, and Bernhart Schwenk.
*Gillian Wearing: Family History*. London: Film and Video
    Umbrella and Maureen Paley, 2007. Texts by Steven
    Bode, Stuart Comer, and Paul Morley.
Gioni, Massimiliano. "Gillian Wearing: Drunk."
    In *Defining Contemporary Art: 25 Years in 200 Pivotal
    Artworks*, 254–55. London: Phaidon, 2011.

## Christopher Williams

Born 1956 in Los Angeles
Lives in Cologne and Los Angeles

### SOLO EXHIBITIONS

2014
*Christopher Williams: The Production Line of Happiness*,
    The Museum of Modern Art, New York. Traveled
    to The Art Institute of Chicago and Whitechapel
    Gallery, London. Exh. cat.

2007
*For Example: Dix-Huit Leçons Sur La Société Industrielle
    (Revision 6)*, Kunsthalle Zürich. Exh. cat.

2005
*De Rijke/De Rooij*, Secession, Vienna. Exh. cat.
*For Example: Dix-Huit Leçons sur la Société Industrielle
    (Draft 2)*, Contemporary Art Gallery, Vancouver.
    Exh. cat.
*For Example: Dix-Huit Leçons sur la Société Industrielle
    (Revision 1)*, Kunstverein Braunschweig, Germany.
    Exh. cat.

2000
*For Example: Die Welt ist schön (Revision 22): Couleur
    Européene, Couleur Soviétique, Couleur Chinoise*,
    Museum Haus Lange–Haus Esters, Krefeld,
    Germany. Exh. cat.

1997
*For Example: Die Welt ist schön (Revision 9): A retrospective
    from the first draft to the final draft*, Museum Boijmans
    Van Beuningen, Rotterdam, Netherlands.
    Traveled to Kunsthalle Basel, Switzerland. Exh. cat.
*For Example: Die Welt ist schön (Revision 10): A retrospective
    from the first draft to the final draft*, Kunsthalle Basel,
    Switzerland. Exh. cat.

1993
*For Example: Die Welt ist schön (First Draft)*, Kunstverein
    München, Munich

### BIBLIOGRAPHY

*Christopher Williams: Printed in Germany*. Cologne: Verlag
    der Buchhandlung Walther König, 2014.
*Christopher Williams: The Production Line of Happiness*.
    Chicago: The Art Institute of Chicago; New York:
    The Museum of Modern Art; and London:
    Whitechapel Gallery, 2014. Texts by Mark Godfrey,
    Roxana Marcoci, Christopher Williams, and
    Matthew S. Witkovsky.
Karola Kraus, ed. *Christopher Williams. For Example:
    Dix-Huit Leçons Sur La Société Industrielle (Revision 11)*.
    Cologne: Verlag der Buchhandlung Walther König,
    2010. Text by Mark Godfrey.

Roe Ethridge
*Yellow Phone*, 2013

Lucas Blalock

*Broken Composition*, 2011
Chromogenic print
19 ½ × 24 in. (49.5 × 61 cm)
Courtesy of the artist and Ramiken Crucible,
New York
PAGE 71

Clegg & Guttmann

*Grand Master*, 1982
Silver dye bleach print
70 ⅟₁₆ × 48 ⅟₁₆ in. (178 × 122.1 cm)
The Metropolitan Museum of Art, New York; Gift of Eve
Feuer Urvater, in memory of Ronald M. Urvater, 2014
PAGE 51

*Portrait of two sisters*, 2006
Lambda print mounted behind Plexiglas, MDF frame
61 × 45 ¼ × 2 ⅜ in. (155 × 115 × 6 cm) (framed)
Courtesy of Galerie Elisabeth & Klaus Thoman,
Innsbruck/Vienna
PAGE 123

Lynn Davis

*Iceberg 32, Disko Bay, Greenland*, 2000
Gelatin silver print, toned with gold
36 × 36 in. (91.4 × 91.4 cm)
Courtesy of the artist
PAGE 19

*Iceberg III, Disko Bay, Greenland*, 2004
Gelatin silver print, toned with gold
36 × 36 in. (91.4 × 91.4 cm)
Courtesy of the artist
PAGE 20

*Iceberg IX, Disko Bay, Greenland*, 2004
Gelatin silver print, toned with gold
36 × 36 in. (91.4 × 91.4 cm)
Courtesy of the artist
PAGE 21

Thomas Demand

*Diving Board (Sprungturm)*, 1994
Chromogenic color print
59 ¹⁄₁₆×46 ⁷⁄₁₆ in. (150×118 cm)
Courtesy of the artist and Matthew Marks, New York
and Los Angeles
PAGE 63

*Daily #11*, 2009
Framed dye transfer print
28 ⁷⁄₈×32 ⁷⁄₁₆ in. (73.4×82.4 cm) (framed)
Courtesy of the artist and Matthew Marks, New York
and Los Angeles
PAGE 2

*Daily #13*, 2011
Framed dye transfer print
23 ¹⁵⁄₁₆×27 ⁵⁄₁₆ in. (60.8×69.3 cm) (framed)
Courtesy of the artist and Matthew Marks, New York
and Los Angeles
PAGE 64

*Daily #14*, 2011
Framed dye transfer print
39 ½×31 ½ in. (100.2×79.9 cm) (framed)
Courtesy of the artist and Matthew Marks, New York
and Los Angeles
PAGE 65

*Daily #17*, 2011
Framed dye transfer print
24 ⅛×33 ⅜ in. (61.3×84.8 cm) (framed)
Courtesy of the artist and Matthew Marks, New York
and Los Angeles
PAGE 66 AND BACK COVER

*Daily #21*, 2013
Framed dye transfer print
23 ½×17 ⅞ in. (59.7×45.4 cm) (framed)
Courtesy of the artist and Matthew Marks, New York
and Los Angeles
PAGES 27 AND 67

Stan Douglas

*Hastings Park, 16 July 1955*, 2008
Digital C-print mounted on Dibond aluminum
60×89 ¼ in. (152.4×226.7 cm)
Hort Family Collection
PAGE 73

Roe Ethridge

*Myla with Column*, 2008
Chromogenic print
55×42 in. (139.7×106.7 cm)
Courtesy of the artist and Andrew Kreps Gallery,
New York
PAGE 89

*Thanksgiving 1984*, 2009
Chromogenic print
44×34 in. (111.8×86.4 cm)
Courtesy of the artist and Andrew Kreps Gallery,
New York
PAGE 90

*Yellow Phone*, 2013
Chromogenic print
34 ¾×45 ⅞ in. (88.3×116.5 cm)
Collection of Andrew Marks, New York
PAGE 114

*Peas and Pickles*, 2014
Dye sublimation print on aluminum
49 ½×33 in. (125.7×83.8 cm)
Courtesy of the artist and Andrew Kreps Gallery,
New York
PAGE 91

Rodney Graham

*Dead Flowers in My Studio*, 2009
Painted aluminum light box with transmounted
chromogenic transparency
52 ⅜×40 ¾×7 ¼ in. (133×103.5×18.4 cm) overall
Hammer Museum, Los Angeles; Gift of Gail
and Stanley Hollander
PAGE 45

*Small Basement Camera Shop circa 1937*, 2011
Painted aluminum light box with transmounted
chromogenic transparency
71 ½×71 ½×7 in. (181.6×184.2×17.8 cm) overall
Collection Museum of Contemporary Art Chicago;
Gift of Mary and Earle Ludgin by exchange, in honor
of Donald Young
PAGE 6

## Andreas Gursky

*Alba*, 1989
C-print, Diasec
87 × 108 7/8 × 2 3/8 in. (221 × 276.5 × 6 cm) (framed)
Collection of Alan Hergott and Curt Shepard
PAGE 29

## Peter Holzhauer

*Kodiak*, 2001
Gelatin silver print
13 1/4 × 19 7/8 in. (33.7 × 50.5 cm)
Hammer Museum, Los Angeles; Purchase
PAGE 96

*Cerritos*, 2008
Chromogenic print
30 × 38 in. (76.2 × 96.5 cm)
Courtesy of the artist
PAGE 97

*Orange Street*, 2011
Archival inkjet print
25 × 32 in. (63.5 × 81.3 cm)
Courtesy of the artist
PAGE 99

## Annette Kelm

*First Picture for a Show*, 2007
Chromogenic print
6 1/4 × 7 3/4 in. (15.9 × 19.7 cm)
Collection of Allison Wong
FRONT COVER AND PAGE 35

Untitled, 2007
Suite of four chromogenic prints
25 1/4 × 20 1/2 in. (64.1 × 52.1 cm) each
The Museum of Contemporary Art, Los Angeles;
Purchased with funds provided by the
Photography Committee
PAGES 36–37

## Elad Lassry

*Melocco*, 2009
Chromogenic print, painted frame
11 1/2 × 14 1/2 × 1 1/2 in. (29.2 × 36.8 × 3.8 cm) (framed)
Collection of Viet-Nu Nguyen, Los Angeles
PAGE 94

*Man (With Circles)*, 2010
Chromogenic print, painted frame
14 1/2 × 11 1/2 × 1 1/2 in. (36.8 × 29.2 × 3.8 cm) (framed)
Collection of David Simkins
PAGE 95

*Selkirk Rex, LaPerm*, 2011
Chromogenic print diptych, painted frames
14 1/2 × 11 1/2 × 1 1/2 in. (36.8 × 29.2 × 3.8 cm) each (framed)
Rubell Family Collection, Miami
PAGE 128

*Chocolate Bars, Eggs, Milk*, 2013
Chromogenic print, painted frame
14 1/2 × 11 1/2 × 1 1/2 in. (36.8 × 29.2 × 3.8 cm) (framed)
Collection of Matthew and Sarah Rothman
PAGE 93

## Sharon Lockhart

*Goshogaoka Girls Basketball Team: Kumi Nanjo and Marie
Komuro; Rie Ouchi; Atsuko Shinkai, Eri Kobayashi and Naomi
Hasegawa*, 1997
Three framed chromogenic prints
32 5/16 × 27 3/8 in. (82.1 × 69.5 cm) each (framed); installed
dimensions variable
Walker Art Center, Minneapolis; T. B. Walker
Acquisition Fund, 2002
PAGES 60–61

## Florian Maier-Aichen

*La Brea Avenue in the Snow*, 2011
Chromogenic print
65 5/8 × 81 3/4 in. (166.7 × 207.6 cm)
Courtesy of the artist and Blum & Poe, Los Angeles
PAGE 69

## Robert Mapplethorpe

*Lily*, 1979/2006
Gelatin silver print
13 ¾ × 13 ¾ in. (35 × 35 cm) (image);
19 ¹³⁄₁₆ × 15 ¾ in. (50.3 × 40 cm) (sheet)
Promised Gift of The Robert Mapplethorpe Foundation
to The J. Paul Getty Trust and the Los Angeles County
Museum of Art
PAGE 23

*Orchid*, 1982/2005
Gelatin silver print
15 ⅜ × 15 ⅛ in. (39 × 38.4 cm) (image);
19 ¹³⁄₁₆ × 15 ¹³⁄₁₆ in. (50.3 × 40.2 cm) (sheet)
Promised Gift of The Robert Mapplethorpe Foundation
to The J. Paul Getty Trust and the Los Angeles County
Museum of Art
PAGE 22

## McDermott & McGough

*Those Moments, 1955*, 2010
Tricolor carbon print
30 × 23 ½ in. (76.2 × 59.7 cm)
Courtesy of the artists and Cheim & Read, New York
PAGE 75

## Catherine Opie

*Lawrence*, 2012
Pigment print
33 × 25 in. (83.8 × 63.5 cm)
Collection of Barbara Ruben, Chicago
PAGE 54

*Lawrence (Black Shirt)*, 2012
Pigment print
33 × 25 in. (83.8 × 63.5 cm)
Collection of Rosette V. Delug, Los Angeles
PAGE 55

## Barbara Probst

*Exposure #70: Munich studio, 05.10.09, 3:03 p.m.*, 2009
Ultrachrome ink on cotton paper
Two parts: 24 × 24 in. (61 × 61 cm) each
Collection of Jason Frank and Jerry Johnson
PAGE 31

*Exposure #87: N.Y.C., 401 Broadway, 03.15.11,
4:22 p.m.*, 2011
Ultrachrome ink on cotton paper
Three parts: 36 ¼ × 53 ¹⁵⁄₁₆ in. (92 × 137 cm) each
Private collection
PAGES 32–33

## Thomas Ruff

*Porträt (H. Hausmann)*, 1988
Chromogenic print
83 × 65 in. (210.8 × 165.1 cm)
Museum of Contemporary Art Chicago;
Gerald S. Elliot Collection
PAGE 48

*Porträt (P. Stadtbäumer)*, 1988
Chromogenic print
70 ⅞ × 63 in. (180 × 160 cm)
Collection of Linda and Bob Gersh, Los Angeles
PAGE 47

*Porträt (E. Denda)*, 1989
Chromogenic print
83 × 65 in. (210.8 × 165.1 cm)
Private collection, courtesy of David Zwirner,
New York/London
PAGE 49

## Andres Serrano

*Klansman (Imperial Wizard III)*, 1990
Cibachrome print
60 × 49 ½ in. (152.4 × 125.7 cm)
Collection of the Modern Art Museum of Fort
Worth; Museum purchase made possible by a grant
from The Burnett Foundation
PAGE 53

## Hiroshi Sugimoto

*Conceptual Forms 0003*
*Dini's Surface: a surface of constant negative curvature
obtained by twisting a pseudosphere*, 2004
Gelatin silver print
58 ¾ × 47 in. (149.2 × 119.4 cm)
Courtesy of the artist and Pace Gallery
PAGE 15

Wolfgang Tillmans

*window New Inn Yard*, 1997
Chromogenic print
80 11/16 × 57 1/16 × 2 3/8 in. (205 × 145 × 6 cm) (framed)
Hammer Museum, Los Angeles; Purchase
PAGE 39

Jeff Wall

*Diagonal Composition*, 1993
Transparency in light box
15 3/4 × 18 1/8 in. (40 × 46 cm)
Collection of the artist, Vancouver
PAGES 27 AND 41

*A view from an apartment*, 2004–05
Transparency in light box
65 3/4 × 96 1/16 in. (167 × 244 cm)
Collection of the artist, Vancouver
PAGE 42

*Boxing*, 2011
Color photograph
84 5/8 × 116 1/8 in. (215 × 295 cm)
Collection of the artist, Vancouver
PAGE 43

Gillian Wearing

*Self-Portrait as my Father, Brian Wearing*, 2003
Gelatin silver print
64 5/8 × 51 3/8 in. (164 × 130.5 cm)
Heather Podesta Collection
PAGE 59

*Self-Portrait as my Mother, Jean Gregory*, 2003
Gelatin silver print
53 1/8 × 45 5/8 in. (134.9 × 115.9) (framed)
Museum of Contemporary Art Chicago; Restricted gift
of Collectors Forum in memory of Tom Ruben
PAGE 58

Christopher Williams

*Department of Water and Power*
*General Office Building, dedicated*
*on June 1, 1965*
*Albert C. Martin and Associates*
*May 18, 1994*
*(Nr. 1 and Nr. 2)*, 1994
Two gelatin silver prints
Diptych: 14 × 11 in. (35.6 × 27.9 cm) each
Hammer Museum, Los Angeles;
Gift of Patrick Painter and Soo Jin Jeong-Painter
PAGES 78–79

*Untitled (Study in Yellow and Green/East Berlin)*
*Studio Thomas Borho, Düsseldorf, July 7th, 2012*, 2012
Inkjet print on cotton rag paper
14 3/8 × 18 in. (36.5 × 45.7 cm)
Private Collection; courtesy of David Zwirner,
New York/London
PAGES 27 AND 81

*TecTake Luxus Strandkorb grau/weiß*
*Model no.: 400636*
*Material: wood/plastic*
*Dimensions (height/width/depth): 154 cm × 116 cm × 77 cm*
*Weight: 49 kg*
*Manufactured by Ningbo Jin Mao Import & Export Co., Ltd,*
*Ningbo, Zhejiang, China for TecTake GmbH,*
*Igersheim, Germany*
*Model: Zimra Geurts, Playboy Netherlands Playmate of*
*the Year 2012*
*Studio Rhein Verlag, Düsseldorf*
*February 1, 2013*
*(Zimra stretching)*, 2013
Selenium-toned gelatin silver print
19 7/8 × 23 3/4 in. (50.5 × 60.3 cm)
Hammer Museum, Los Angeles; Purchase
PAGE 83

*Interflug Model: Iljuschin IL-62*
*Flight number: IF 882*
*Departure: 3:30 pm, SXF – Berlin Schönefeld, Berlin, German Democratic Republic*
*Arrival: 5:40 pm, ALG – Houari Boumediene Airport, Algiers, Algeria*
*Sunday, August 28, 1983*
*Studio Rhein Verlag, Düsseldorf*
*October 21, 2013*, 2014
Inkjet print on cotton rag paper
14 1/2 × 18 in. (36.8 × 45.7 cm)
Courtesy of David Zwirner, New York/London,
and Galerie Gisela Capitain, Cologne
PAGE 80

Lucas Blalock
*Both Chairs in CW's Living Room*, 2012
Chromogenic print
51 ¼ × 40 ¼ in. (130 × 102 cm)
Courtesy of the artist and Ramiken Crucible
PAGE 70

Stan Douglas
*Ballantyne Pier, 18 June 1935*, 2008
Digital chromogenic print mounted on Dibond
aluminum
45 × 116 in. (114.3 × 294.6 cm)
Courtesy the artist and David Zwirner, New York
PAGE 72

William Eggleston
Untitled (from 14 Pictures), published 1974
Dye-transfer print
16 × 20 in. (40.6 × 50.8 cm)
Courtesy Cheim & Read, New York
PAGE 86

Harun Farocki
Film stills from *Ein Bild (An Image)*, 1983
16mm film, color, sound
25 min.
Harun Farocki Filmproduktion
PAGE 82

Andreas Gursky
*Ruhrtal*, 1989
Chromogenic print
35 × 78 ¹⁵⁄₁₆ × 1 ¹⁵⁄₁₆ in. (89 × 200.5 × 5 cm)
Courtesy of Sprüth Magers Berlin London
PAGE 28

Dorothea Lange
*Pea picker from Texas*, 1935
Photographic print
PAGE 24

Sharon Lockhart
Untitled, 1996
Framed chromogenic print
51 × 40 in. (129.5 × 101.6 cm) (framed)
Hammer Museum, Los Angeles; Gift of Ellen Kern
PAGE 125

Sharon Lockhart
Untitled, 2010
Framed chromogenic print
38 × 50 in. (97 × 127 cm) (framed)
Courtesy of the artist and Blum & Poe, Los Angeles
PAGE 57

The Los Angeles Fine Arts Squad (painted by Victor
Henderson, Terry Schoonhoven, and James Franzin)
*Venice in the Snow*, June–November 1970
1905 Oceanfront Walk, Venice, California
(obscured by an apartment complex in 1972, painted
out afterwards)
19 × 70 ft. (5.8 × 21.3 m)
Commissioned by Jerry Rosen
PAGE 68

John McCracken
*Red Plank*, 1969
Wood, fiberglass, and lacquer
96 ⅛ × 22 ¼ × 3 ⅛ in. (244.1 × 56.6 × 7.9 cm)
The Art Institute of Chicago; Twentieth-Century
Purchase Fund, 1970.294
PAGE 11

Daido Moriyama
*KARIUDO (Hunter)*, 1972
Black-and-white print
Courtesy of the artist, Luhring Augustine, New York,
and Taka Ishii Gallery, Tokyo
PAGE 17 BOTTOM

Paul Outerbridge
*Window with Plants*, 1937
Three-color carbo print
14 ⅝ × 11 ¾ in. (37.2 × 29.8 cm)
Collection of Carol Littleton and John Bailey
PAGE 85

Oscar Gustave Rejlander
*The Two Ways of Life*, 1857
Combination albumen print
15 15/16 × 30 5/8 in. (40.6 × 77.8 cm)
Royal Photographic Society/National Media Museum/
Science & Society Picture Library
PAGE 13

Albert Renger-Patzsch
*Iron Hand, Essen*, 1929
Gelatin silver print
14 13/16 × 10 3/4 in. (37.6 × 27.3 cm)
The Museum of Modern Art, New York; Thomas
Walther Collection, Gift of Shirley C. Burden, by
exchange
PAGE 76

Hiroshi Sugimoto
*Conceptual Forms 0012*
*Diagonal Clebsch surface, cubic with 27 lines*, 2004
Gelatin silver print
58 3/4 × 47 in. (149.2 × 119.4 cm)
Courtesy of the artist and Pace Gallery, New York
PAGE 14

William Henry Fox Talbot
*The Open Door*, before May 1844
Salted paper print from paper negative
5 5/8 × 7 5/8 in. (14.3 × 19.4 cm)
The Metropolitan Museum of Art, New York;
Gilman Collection, Purchase, Joseph M. Cohen
and Robert Rosenkranz Gifts, 2005
PAGE 12

Jeff Wall
*Blind Window no. 3*, 2000
Transparency in light box/chromogenic print
15 3/4 × 20 in. (40 × 51 cm)/9 1/4 × 11 5/8 in. (23.5 × 29.5 cm)
Courtesy of the artist
PAGE 40

Jeff Wall
*Intersection*, 2008
Color photograph
79 1/2 × 99 1/4 in. (202 × 252 cm)
Courtesy of the artist
PAGE 25

Edward Weston
*Epilogue*, 1919
Platinum or palladium print
9 5/8 × 7 3/8 in. (24.5 × 18.7 cm)
Collection Center for Creative Photography, Tucson,
Arizona; Johan Hagemeyer Collection/Purchase
PAGE 16

Garry Winogrand
*World's Fair, New York City*, 1964, from the portfolio
Women Are Beautiful, 1981
Gelatin silver print
8 3/4 × 13 1/8 in. (22.2 × 33.3 cm) (image);
11 × 14 in. (27.9 × 35.4 cm) (sheet)
The Estate of Garry Winogrand; courtesy Fraenkel
Gallery, San Francisco
PAGE 17 TOP

This exhibition and catalogue would not be possible without the support of many people and institutions. I am deeply grateful to everyone who helped bring *Perfect Likeness* to fruition.

First, I would like to join Ann Philbin, the Hammer's director, in thanking the generous funders of the exhibition and publication: Eugenio Lopez; Susan Steinhauser and Daniel Greenberg/The Greenberg Foundation; The Andy Warhol Foundation for the Visual Arts; The Audrey and Sydney Irmas Charitable Foundation; the National Endowment for the Arts; Trish and Jan de Bont; Margo Leavin; Pasadena Art Alliance; The Robert Mapplethorpe Foundation; Contemporary Collectors–Orange County; Cyndee Howard and Lesley Cunningham; Suzanne Deal Booth; and Matthew Marks Gallery. I truly appreciate their support.

Once again, artists, museums, individual collectors, and galleries have been extraordinarily kind in making their work available to be seen in a Hammer exhibition. My profound gratitude goes to the lenders to the exhibition, who are listed separately following these acknowledgments. Their tremendous generosity makes this exhibition possible.

My colleagues at the Hammer have provided invaluable support. My thanks go first of all to Ann Philbin, who has enthusiastically endorsed the project from the beginning. At every step of the way to the realization of the exhibition and this publication I have relied on the dedicated work of curatorial associate Emily Gonzalez-Jarrett; *Perfect Likeness* would have been impossible without her commitment, resourcefulness, and thoughtful suggestions. She has my deepest appreciation. My colleagues in the Hammer's curatorial department were also supportive and helpful, and my thanks go to deputy director of curatorial affairs Cynthia Burlingham, chief curator Connie Butler, senior curator Anne Ellegood, curators Aram Moshayedi and Ali Subotnick, and administrative coordinator Michael Nock. Jennifer Wells Green, deputy director of advancement, and her development team did great work on generating support for the show. Melanie Crader, director of exhibition and publication management, and her predecessor Brooke Hodge took on countless administrative and logistical issues for both the exhibition and the publication. Director of registration and collections management Portland McCormick, Alex Bancroft, and Jennifer Garpner handled the complex shipping of works from all over the United States and Europe with the professionalism and calm that they always bring. I am grateful to Peter Gould, assistant director of exhibition design and production, for his work on the configuration of the galleries, and to chief preparator Jason Pugh and his team. I extend my thanks also to chief communications officer Gia Storms and her staff, as well as director of public programs Claudia Bestor and Darin Klein for their work on public programs in conjunction with the show.

I am very happy to have been able to work on this book with many longtime collaborators who have made its production a pleasure for me. My deep appreciation goes to Lorraine Wild and Marina Mills Kitchen of Green Dragon Office for their superb design. Jane Hyun edited my text with the insight and attention to every detail that I always expect from her. Courtney Smith at the Hammer worked tirelessly on coordinating the production of this publication. Rusty Sena and his team at Echelon did a great job on the color separations in Los Angeles. Jeff Baker and his team at Shapco brought the catalogue through to completion. And I am very pleased to work again with Mary DelMonico at DelMonico Books/Prestel to copublish this book.

Many people answered myriad questions and provided information and help of every kind to make this project happen. I am indebted to Jackie Maman at The Art Institute of Chicago; Teal Baker; Maria Bierwirth; Tim Blum, Jeff Poe, and Sam Kahn at Blum & Poe; Annie Rochfort at Tanya Bonakdar Gallery; Josef Bull; Traci Cannon; Tammy Carter at the Center for Creative Photography; Karen Polack and Maria

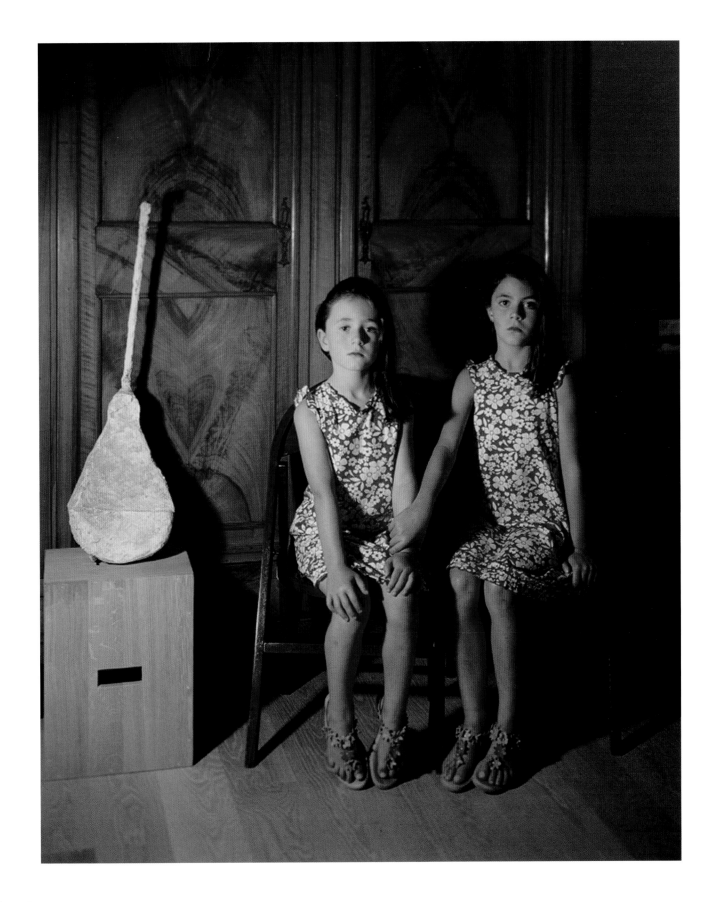

Clegg & Guttmann
*Portrait of two sisters*, 2006

Bueno at Cheim & Read; the Clegg & Guttmann Studio; Owen Conway; Kevin Doherty; Esther Dörring; Matthias Rajmann at Harun Farocki Filmproduktion; Marc Foxx; Rebecca Herman at Fraenkel Gallery, San Francisco; Jacklyn Burns, Grace Murakami, Miriam Katz, and Paul Martineau at the Getty Museum; Alex Glauber; Aiko Hachisuka; Susan Hawkins at G. Ray Hawkins Gallery; Heike Holona; Rebeccah Johnson; Iris Ströbel at Johann König, Berlin; David Kordansky, Alexis Kerin, Maisey Cox, and William Parks at David Kordansky Gallery; Andrew Kreps, Lawren Joyce, and Liz Mulholland at Andrew Kreps Gallery; Yvon Lambert Gallery; Julianne Lee; Julia Loeschl; Joree Adilman at The Robert Mapplethorpe Foundation; Doug Eklund, Anna Wall, and Emily Foss at the Metropolitan Museum of Art; Gabriela Mizes; Allie Heath at the Modern Art Museum of Fort Worth; Janice Guy, Fabiana Viso, and Sonel Breslav at Murray Guy; Madeleine Grynsztejn, Michael Darling, and Analú López at the Museum of Contemporary Art Chicago; Philippe Vergne, Bennett Simpson, and Gladys-Katherina Hernando at the Museum of Contemporary Art, Los Angeles; Alexandra Porter, Lindsay McGuire, and Kelly Reynolds at Pace Gallery; Julia Künzi at Galerie Francesca Pia; Blaize Lehane at Ramiken Crucible; Shaun Caley Regen, Jennifer Loh, and Jose Luis G. Lopez at Regen Projects; Jasmine Rodgers at the Royal Photographic Society/National Media Museum/Science & Society Picture Library; Juan Roselione-Valdez at the Rubell Family Collection; Andrew Silewicz, Annette Völker, Franziska von Hasselbach, and Sarah Watson at Sprüth Magers Berlin London; Lea Stoll at Galerie Elisabeth & Klaus Thoman; Olga Viso at Walker Art Center; David Zwirner, Angela Choon, Bellatrix Hubert, Veronique Ansorge, Justine Durrett, Carolyn McDermott, and Megan Bedford at David Zwirner; and Cristian Alexa, Jessica Heerten, and Robbie McDonald at 303 Gallery.

In the course of planning *Perfect Likeness*, I had many enlightening conversations with friends and colleagues that shaped the content of the project. My deep appreciation for those discussions goes to Roy Arden, Julie Ault, Nana Bahlmann, George Baker, Jack Bankowsky, Martin Beck, Frank Benson, Walead Beshty, Jennifer Blessing, Kerry Brougher, Lynne Cooke, Geoff Dyer, Thomas Eggerer, Andrea Fraser, Michael Fried, Gary Garrels, Silvia Gaspardo Moro, Ann Goldstein, Piero Golia, Michael Govan, David Joselit, Tom Kennedy, Alex Klein, Owen Kydd, Pamela Lee, Nancy Lim, Christian Marclay, Micki Meng, Nicole Miller, John Morace, Rebecca Morse, Mariko Munro, Petr Nedoma, Sandra Phillips, Rick Pirro, Charles Ray, Stephanie Rosenthal, Ingrid Schaffner, Alex Slade, James Welling, Rebecca Wilson, Wendy Yao, and Lydia Yee.

Many of my most important conversations, of course, were with the artists included in the exhibition. I owe the greatest thanks to them, for their thoughtfulness, their willingness to participate in this show, and above all for their work.

I dedicate this exhibition and book to the memory of Karin Higa.

RUSSELL FERGUSON

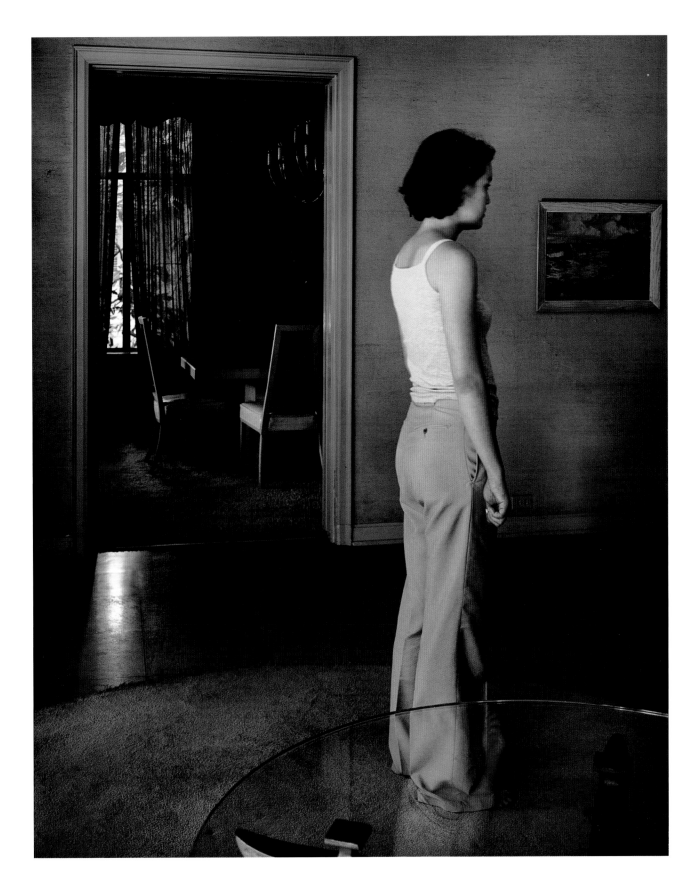

Sharon Lockhart
Untitled, 1996

# REPRODUCTION CREDITS

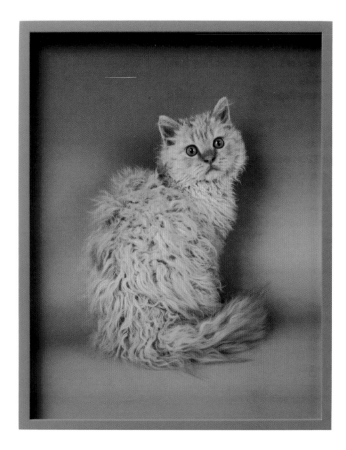
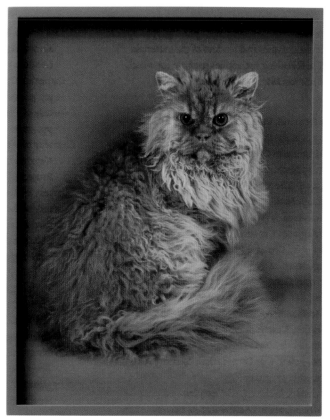

Published on the occasion of the exhibition
*Perfect Likeness: Photography and Composition*, organized
and presented by the Hammer Museum, Los Angeles,
June 20–September 13, 2015.

This exhibition is organized by adjunct curator Russell
Ferguson. The curatorial associate for the exhibition
is Emily Gonzalez-Jarrett.

*Perfect Likeness* is made possible by gifts from Eugenio
Lopez, Susan Steinhauser and Daniel Greenberg/
The Greenberg Foundation, and The Andy Warhol
Foundation for the Visual Arts.

Major support is provided by The Audrey and Sydney
Irmas Charitable Foundation and the National
Endowment for the Arts. Generous funding is provided
by Trish and Jan de Bont, Margo Leavin, Pasadena
Art Alliance, The Robert Mapplethorpe Foundation,
Contemporary Collectors - Orange County, Cyndee
Howard and Lesley Cunningham, and Suzanne Deal
Booth. Additional support for the catalogue is provided
by Matthew Marks Gallery.

Designer: Lorraine Wild and Marina Mills Kitchen,
    Green Dragon Office, Los Angeles
Editor: Jane Hyun
Proofreader: Dianne Woo
Publication coordinator: Courtney Smith
Color separations: Echelon, Santa Monica, California
Printer: The Avery Group at Shapco Printing,
    Minneapolis

This book is typeset in Lexicon.

ABOVE  Elad Lassry, *Selkirk Rex, LaPerm*, 2011
FRONT COVER  Annette Kelm, *First Picture for a Show*, 2007
BACK COVER  Thomas Demand, *Daily #17*, 2011

ISBN: 978-3-7913-5319-7

Library of Congress Cataloging-in-Publication Data
Ferguson, Russell, author.
Perfect likeness : photography and composition / Russell
Ferguson.
    pages cm
Includes bibliographical references.
ISBN 978-3-7913-5319-7 (hardback)
1. Composition (Photography). I. Title.
TR179.F47 2015
770–dc23

Published in 2015 by the Hammer Museum
and DelMonico Books • Prestel

Hammer Museum
10899 Wilshire Boulevard
Los Angeles, CA 90024-4201
310 443 7000
www.hammer.ucla.edu

The Hammer Museum is operated and partially funded
by the University of California, Los Angeles. Occidental
Petroleum Corporation has partially endowed the Museum
and constructed the Occidental Petroleum Cultural Center
Building, which houses the Museum.

DelMonico Books, an imprint of Prestel, a member of
Verlagsgruppe Random House GmbH

Prestel Verlag
Neumarkter Strasse 28
81673 Munich
Tel.: +49 89 4136 0
Fax: +49 89 4136 2335

Prestel Publishing Ltd.
14-17 Wells Street
London W1T 3PD
Tel.: +44 20 7323 5004
Fax: +44 20 7323 0271

Prestel Publishing
900 Broadway, Suite 603
New York, NY 10003
Tel.: +1 212 995 2720
Fax: +1 212 995 2733
sales@prestel-usa.com

www.prestel.com